IMAGES
of America

BELLA VISTA

TO YOU,,,
,,WHO LOVE THE GREAT
OUT-OF-DOORS, THE OPEN
SPACES, THE PEACEFUL,
THE QUIET, THE RESTFUL,
THE PURE FRESH AIR, THE
NEARNESS TO NATURE,
THE SHADY NOOK, THE
CLEAR COOL STREAM AND
THE DEEP BLUE HOLES ⌒ ⌒
⌒ THE PLEASURE OF BATH-
ING, ROWING, HUNTING,
FISHING, DANCING, TENNIS,
GOLFING, EXPLORING, RID-
ING, HIKING, MOTORING,
CLIMBING ,,,,, OR ANY
OTHER CLEAN SPORT OR
RECREATION, BELLA VISTA
IS FOREVER DEDICATED

F.W. Linebarger Plaque. These words were written by Forrest W. Linebarger, one of the three Linebarger brothers who bought the Bella Vista Summer Resort in 1917. It was part of the tremendous advertising campaign used by the brothers to sell lots and cottages at the resort. These words, as true today as they were then, are the cornerstone of life in Bella Vista and the valley of Little Sugar Creek. (Bella Vista Historical Society.)

On the Cover: Lake Pavilion. One of the most enjoyable activities at the Bella Vista Summer Resort was swimming. This photograph, probably taken in the early 1920s, shows a summer at the first Lake Pavilion on the shore of Lake Bella Vista. The pavilion was expanded many times and eventually contained 16,000 square feet of enclosed space. This structure was destroyed by fire in 1930; it was replaced by a new smaller pavilion the following year. (Bella Vista Historical Society.)

IMAGES
of America

BELLA VISTA

Xyta Lucas and Dale Phillips

ARCADIA
PUBLISHING

Published by Arcadia Publishing
Charleston, South Carolina

Printed in the United States of America

Library of Congress Control Number: 2020951120

For all general information, please contact Arcadia Publishing:
Telephone 843-853-2070
Fax 843-853-0044
E-mail sales@arcadiapublishing.com
For customer service and orders:
Toll-Free 1-888-313-2665

Visit us on the Internet at www.arcadiapublishing.com

*This book is dedicated to Carole Linebarger Harter and to the many
volunteers who have contributed to the success of the Bella Vista
Historical Society and the Bella Vista Historical Museum since 1976.*

CONTENTS

ACKNOWLEDGMENTS

In creating this book, we would first like to thank all the members of the Bella Vista Historical Society and the citizens of Bella Vista, past and present, without whose help this collection of photographs and information would not have been possible. We also thank the Benton County Historical Society (Arkansas) and the McDonald County Historical Society (Missouri) for their contributions to this work.

A special thanks goes to former Bella Vista Historical Society president Carole Harter, granddaughter of C.A. Linebarger, one of the past owners of the Bella Vista Summer Resort. It is due to her personal commitment to keeping the Bella Vista Historical Society alive over many years that we can bring you this volume. Lillian Green, a world-renowned photographer and C.A. Linebarger's secretary, left us so many wonderful photographs and records of the Linebarger period. We also wish to thank Constance Waddell, daughter of C.A. Linebarger's foreman, Willie T. "Whitey" May, and author of the book *Sally and Me*. Her stories of growing up at the resort are irreplaceable. And a big thanks to Jack and Shirley Kellogg for their work in helping us with the restoration and screening of the photographs. Thanks also to our spouses, Jim Lucas and Carol Phillips, for their support and help with this project. Unless otherwise stated, all images appear courtesy of the Bella Vista Historical Society.

A special thanks goes to all of the employees at Arcadia Publishing, especially Lindsey Givens, Stacia Bannerman, and Sara Miller, for their assistance and patience in helping two first-time authors complete this volume.

Finally, we urge anyone reading this book, especially the citizens of Bella Vista and the surrounding areas of Arkansas, Missouri, and Oklahoma, to help support your local historical societies and museums. When you are cleaning out old boxes, be sure that any photographs, letters, or other historical materials are preserved—the historians and community leaders of the future will be grateful to have this information.

BIBLIOGRAPHY

Benton County Historical Society. The *Pioneer*. Bentonville, AR: Benton County Historical Society, multiple years.

Fite, Gilbert C. *From Vision to Reality, A History of Bella Vista Village 1915–1993*. Rogers, AR: RoArk Printing, Inc., 1993.

Phillips, George H. *The Bella Vista Story*. Bella Vista, AR: The Bella Vista Historical Society, 1980.

Waddell, Constance May. *Sally and Me*. Author House, 2002

INTRODUCTION

Located in the southwest corner of the Ozark Mountains in the valley of Little Sugar Creek, the area that is now the town of Bella Vista, Arkansas, has always been a place of natural beauty and abundant resources. It was first used by Indigenous peoples as a hunting and fishing ground. The valley's magnificent limestone overhangs provided shelter for humans for thousands of years before permanent settlement took place.

Except for a few scattered farms, the area remained isolated until after the Civil War. During the Civil War, the rugged terrain of Little Sugar Creek Valley provided shelter and hiding places for soldiers and civilians supporting both the Union and the Confederacy. Bushwhacking and guerrilla operations echoed through the valley's hollows and streambeds as larger battles raged on its outskirts.

After the Civil War, as more families moved into the valley, its farms began to produce large amounts of dairy products, apples, strawberries, tomatoes, and other staples that would feed residents of the growing city of Bentonville and, later, the Bella Vista Summer Resort. As these families settled into the area, they bonded into communities and began to build churches. The church structures also served as schools and community centers with nearby cemeteries, some of which still dot the landscape of the city of Bella Vista.

In 1915, the Baker family felt that this beautiful valley would be the perfect spot for a recreational resort community. The Bakers built the first dam across Little Sugar Creek to form a lake that they named Bella Vista. The Bakers took on partners but were unable to make the resort successful, so in 1917, they sold the property to the Linebarger Brothers.

The Linebargers created what would become one of the nation's premier summer resorts. They started by building what they called the "bathhouse" next to Lake Bella Vista and several lodges on the hill on the east side of the lake for visitors to stay in. They soon began hiring salesmen to visit prosperous clients in big cities and several nearby states—close enough that they could travel to Bella Vista by train or automobile within a day. Over the years, the Linebargers were successful in selling many of the lots and constructed several hundred cottages for summer residents. They built a nine-hole golf course in 1921, a large swimming pool they named the Plunge in 1924 (this was so popular that it remained open until 1990), and a large hotel called the Sunset in 1929. After Prohibition, in 1935, they also converted a garage (built in 1928) into a winery to sell wine at the Sunset Hotel, in the Wonderland Cave nightclub, and to businesses in nearby towns. The Plunge, as well as the rest of the resort's cabins, lodges, and service buildings, received their water supply from the flow of Big Spring through a system of hydraulic rams installed in 1917. (The remains of one ram can be seen today in the Bella Vista Historical Museum.)

The brothers also converted an extremely large cave into an underground nightclub. The story of Wonderland Cave is one of the most interesting aspects of Bella Vista's history. Inspired by a basement nightclub he visited on a trip to Paris, France, in 1929, C.A. Linebarger developed the idea of building a nightclub in the spacious Wonderland Cave, which he opened in the spring of 1930. The club was a huge success and welcomed regional and national bands that played the popular music of the day. Wonderland Cave went through several reincarnations as a club and a tourist attraction until it was finally closed in 1995.

After suffering a downturn in business due to the Depression in the 1930s and World War II in the 1940s, the Linebargers were hoping for better days. But after the war, as the economy improved, more people were buying automobiles and wanting to travel instead of spending the whole summer in one place, so business did not pick up in the way they had hoped it would.

In 1952, the Linebargers sold most of the property to E.L. Keith, who had moved from Texas in the 1940s and established a successful family resort in nearby Cave Springs, Arkansas. Keith dammed the stream coming out of Big Spring, where the hydraulic rams were located, and built a trout farm northeast of Lake Bella Vista. He converted the second floor of the Dance Pavilion on the edge of the lake into a roller rink, added a miniature golf course and a small snack bar alongside the pool, built a motel and restaurant on the west side of the lake, and offered horseback riding to attract more visitors.

Meanwhile, John Cooper Sr. had established a recreational/development village in eastern Arkansas that he named Cherokee Village. When word leaked that Cooper was looking for a location for a second village in northwest Arkansas, Keith decided to sell the resort to him in 1963. Cooper's company was then called the Cherokee Village Development Company, which was later renamed Cooper Communities. Cooper's vision was to expand the resort into a much larger full-time recreational/retirement community similar to Cherokee Village. After buying up farms in the area north of the Bella Vista resort, he added numerous lakes, golf courses, and other recreational facilities, expanding Bella Vista into a village. The cornerstone of these facilities was the Bella Vista Country Club, which was completed in 1968 and overlooks the golf course built in 1967. Designed by renowned architect Fay Jones, the country club is listed in the National Register of Historic Places.

Continual growth led to Bella Vista attaining the status of a city in 2007. Today, it is home to over 30,000 people of all ages from across North America. While Bella Vista continues to attract retirees, the majority of its residents are now younger people, many of whom moved to the area to work at the nearby international headquarters of Walmart and the local offices of Walmart vendors.

One

THE BEGINNING
1850–1914

The geographical area that now includes the city of Bella Vista was once isolated from permanent human settlement due to its hilly and rocky terrain. With its abundant springs and streams, it was first used by Indigenous peoples as a major hunting and fishing ground. The great limestone overhangs and caves that dotted the landscape provided temporary shelter during these activities. The last major Native American group to use the area for hunting and fishing was the great Osage Nation.

Following the Louisiana Purchase in 1803, the first European Americans began to move into Northwest Arkansas. By the time of the Civil War, only a few scattered farms had emerged in the valley of Little Sugar Creek. During the war, the isolated hollows and caves gave protection to both Union and Confederate supports. Civilians hid themselves and their valuables in the many caves. It is believed that Confederate irregulars, including William Quantrill and Jesse James, used the area as a hiding place during periods of inaction.

Following the Civil War, more settlers entered the area and began building small farms in the valleys and near the springs that drained into Little Sugar Creek. These settlers soon formed small communities, each with a central building that served as a combined school and church where the residents could also gather for community activities. The earliest of these communities were known by the names of Miller (1865), Dug Hill (1868), Rocky Comfort (1884), Summit (1896), and New Home (1896). A man named Wilson Brown moved to the area in 1893 and built a home (named Rago) that he also opened as a general store and post office in 1897.

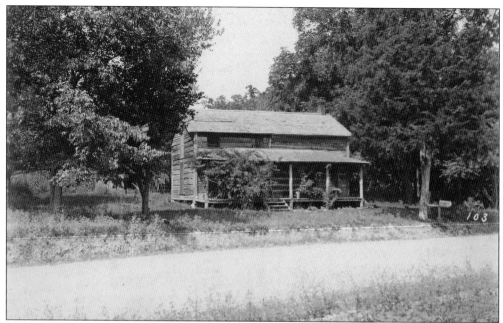

THE J.T. HALE LOG HOUSE. Built around 1853, the Hale Log House is the oldest man-made structure still standing in Bella Vista. It is located on the west side of present-day US Highway 71 at the intersection with Lookout Drive. The log house, built from locally harvested hickory and oak trees, later served as the home of Bella Vista Summer Resort owner C.A. Linebarger.

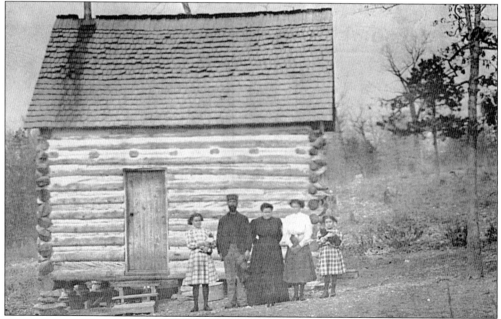

ALLEN FAMILY. This c. 1900 picture of the Allen family shows the simple log homes that were built by post–Civil War settlers in Little Sugar Creek Valley. The abundant first-growth oak, hickory, and pine trees provided the materials for these homes. The Allen home stood near the Dug Hill area of present-day Bella Vista. The many natural flowing springs of the area provided water for drinking and food preservation. (Benton County Historical Society.)

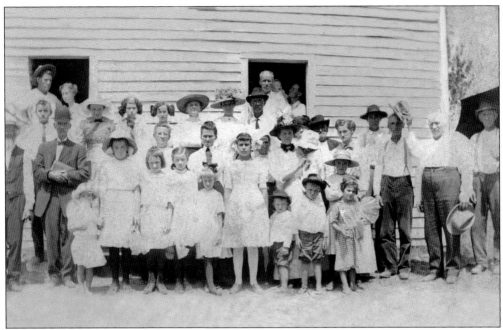

CONGREGATION OF DUG HILL CHURCH OF CHRIST, EARLY 1900s. This church was given the name Dug Hill because of the steps dug into the side of the steep slope leading up to the church building from the valley of Little Sugar Creek. At one time, Dug Hill had three churches and a cemetery. Only the last church, built in 1936, and the cemetery remain. Both are located just southeast of the intersection of US Highway 71 and Lancashire Boulevard (AR 340).

SUMMIT CHURCH AND SCHOOL. This picture shows the Summit Church Congregation around 1916. W.A. Cash and his wife, Jane, donated the land for a building to be used as a school and church in 1896. In the early 1900s, the first log building was replaced by the frame structure shown here. What remained of the building was burned by vandals in 1989. The remaining foundation and cemetery are now the property of the Bella Vista Historical Society.

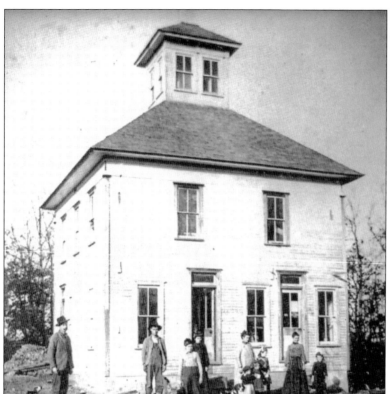

RAGO. Established by Wilson Brown and his family in 1893, Rago began as a 160-acre farm. Within three years, Brown had built the structure shown in these pictures. This served not only as a home for the Brown family but also as a boardinghouse for schoolteachers from nearby Summit, a general store, and a post office. The mail service ended in 1906, but the store continued until 1938.

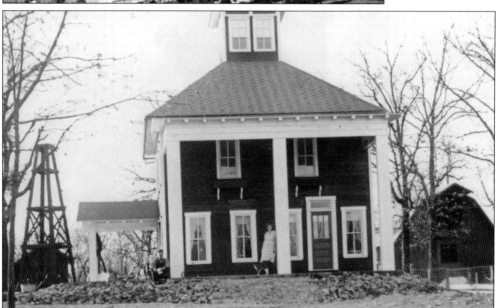

RAGO HOMESTEAD. Rago was known for its orchards, which produced pears, apples, and peaches. The property also included a vineyard, a sawmill, and a silica mine, where the white, powderlike sand was extracted for use in polishing tableware and jewelry. Wilson Brown continued his operation at Rago until his ill health forced him to give it up in 1938. Located in the Metfield area of present-day Bella Vista, this building stood until 1976, when it was burned by an arsonist.

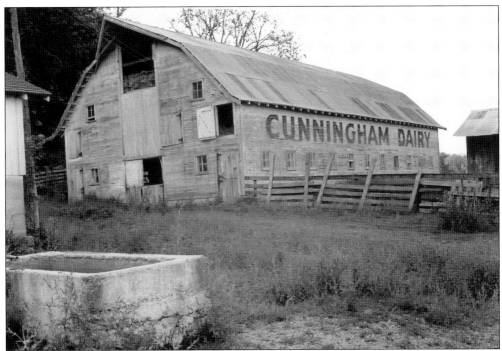

CUNNINGHAM DAIRY FARM. One of the first families to permanently settle in what is now Bella Vista was Thomas and Lutilla Cunningham and their five children. They came from Kansas in 1904 and bought 243 acres of prime bottomland and forested slopes on the west side of Little Sugar Creek. The Cunninghams established a successful dairy that would end up providing many dairy products for the Bella Vista Summer Resort. The farm was located west of the present-day intersection of US Highway 71 and Riordan Road.

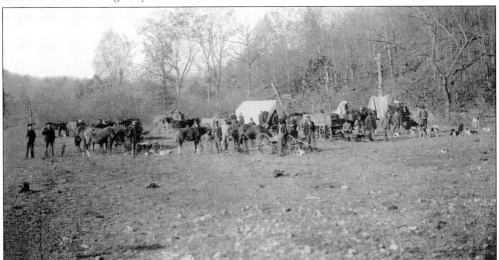

FOX HUNT, 1893. This photograph shows one of the area's most popular pastimes in the years before the resort was built: the fox hunt. The picture was taken in the Pinyon Creek Valley, which is now covered by Lake Ann in the central part of Bella Vista. George and Nancy Pinyon settled in this hollow in 1876. The bottomlands were used for raising crops, and the steep slopes were used for grazing cattle and sheep.

ROBBINS/GORE HOME. George and Nancy Pinyon sold their property in Pinyon Hollow to Neilly and Martha Robbins in 1904, and the Robbinses built this home in 1905 for $2,500. It was a fine house with woodwork all done in cherry. The home was on the hillside just northwest of the present-day Lake Ann dam. It stood until the 1980s, when it was destroyed in a Bella Vista Fire Department training exercise. Only the stone wall is still visible today—it can be seen alongside the hiking trail heading northwest from the dam. (Both, Benton County Historical Society.)

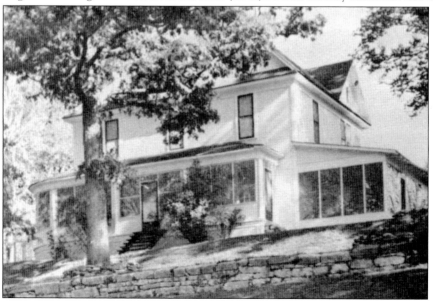

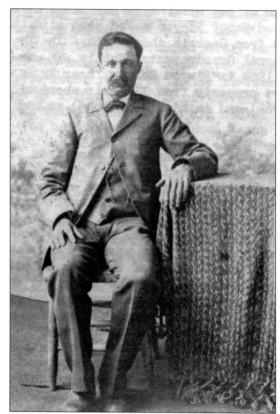

NEILLY AND MARTHA ROBBINS. Neilly James Robbins was born in Sparta, Tennessee, on August 2, 1853. He married Martha Elizabeth Roberts in May 1875 in Bentonville, Arkansas. They lived in Bentonville until 1904, when they bought the property near Little Sugar Creek, and they built their house there in 1905. They sold the property in 1918 and moved back to Bentonville, where Neilly died on January 8, 1919, at age 65. Martha was born in Macon, Missouri, on January 23, 1856. She and her husband had nine children between 1876 and 1901. She died on February 21, 1921, also at age 65. Neilly and Martha are buried in the Bentonville Cemetery in Bentonville. (Both, Benton County Historical Society.)

From left is Ruth the tall one, Mary in front of her, Thomas holding Alice, James (Man), Belle holding Andy, Effie and Lillian Green.

LILLIAN GREEN FAMILY. Another of Bella Vista's first families was Thomas and Belle Green and their seven children. Their farm was located across from Dug Hill on the west side of Little Sugar Creek. This area is now the north end of Kingswood Golf Course. Of special note in this picture is the young girl on the far right, Lillian Green. Lillian was born in 1903 and would later serve as the secretary for Bella Vista Summer Resort owner C.A. Linebarger (see chapter two).

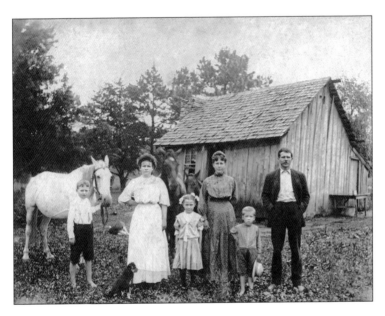

MCCOMBS FAMILY, EARLY 1900S. This photograph shows the McCombs family dressed in their Sunday best. Pictured are Thomas and Mabel McCombs and their children (from left to right) Freddie, Ruby, Lena, and Edward. The family farm was located in the western part of present-day Bella Vista in Dickson Township. (Novella Funk Carlton.)

Melvin Theodore "Ted" and May Funk Wedding, 1908. This picture shows Ted and May Funk on their wedding day in 1908. May was born in Hiwasse, Arkansas, in 1887. As a young girl, she attended Rocky Comfort School, which stood on the present-day site of the Forest Hills Baptist Church in west-central Bella Vista. May was diagnosed with tuberculosis and died in 1922. She requested that she be buried on the school grounds. The following year, her great-uncle died and was buried next to her, and shortly after that, the grave of an infant belonging to a neighboring family was added. The small cemetery is located near the intersection of Forest Hills Boulevard and Sherlock Drive. (Novella Funk Carlton.)

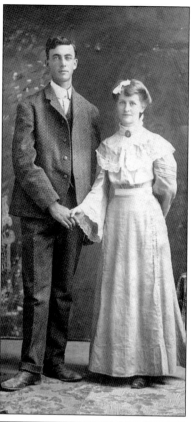

Mills Head Stone. Joseph and Mary Mills were among the first group of families to settle in the Little Sugar Creek area in 1868, after the Civil War. They lived on a farm that became known as Mills Valley. On their property was a large, flowing spring that is now known as the Blowing Springs. The Mills spent their lives in the valley and are buried on a small knoll overlooking their farm and the spring. (Benton County Historical Society.)

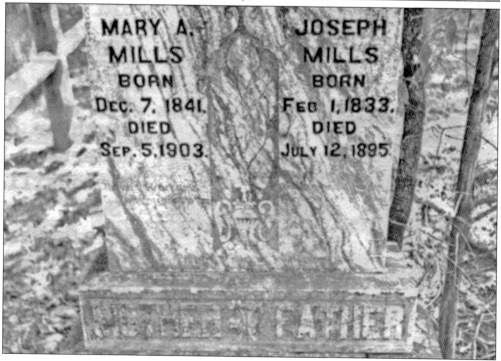

BIG SPRING AND BIG CAVE (NORTH CAVE). The most distinctive geographic feature of Bella Vista is Wonderland Cave. First known as Big Cave or North Cave, this massive cave and the spring that flows from it, known as the Big Spring (pictured above), have been points of interest since Bella Vista's earliest days. In 1868, Capt. J.V. Lee told the *Weekly Arkansas Gazette*, "The cave extends a distance for some nine miles in length, and one chamber alone has a width of over 200 yards, while the distance to the top of the arched roof is upwards of 100 yards." Both the cave and Big Spring have served a multitude of purposes that will be discussed later in this book. The spring has always been one of the major freshwater sources for the area, producing over 500 gallons of water per minute.

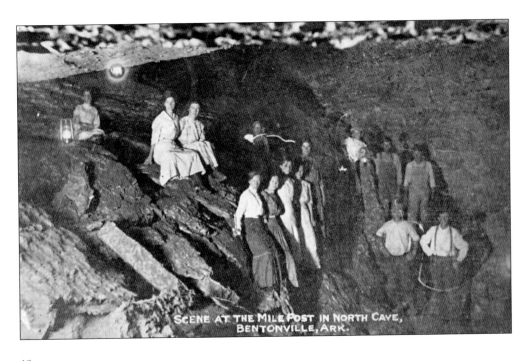

SCENE AT THE MILE POST IN NORTH CAVE, BENTONVILLE, ARK.

GEORGE COTTON, BIG SPRING, 1890s. This photograph shows George Cotton and others at the mouth of Big Spring. Cotton owned the spring and the land around it during this time period. Note the tremendous amount of water coming from the spring. This flow would later provide most—if not all—of the water for resort owners in the area.

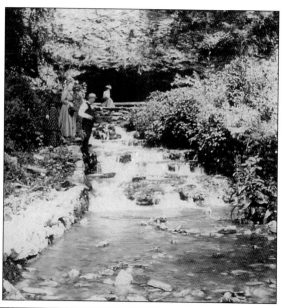

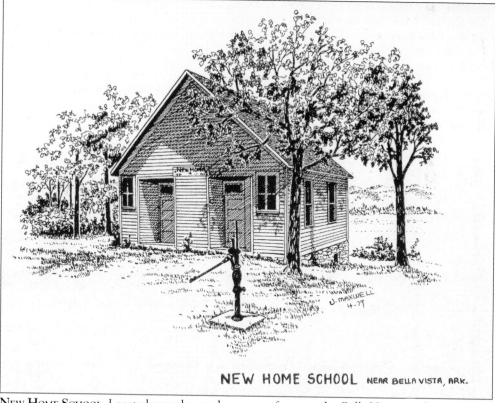

NEW HOME SCHOOL NEAR BELLA VISTA, ARK.

NEW HOME SCHOOL. Located near the southern part of present-day Bella Vista was the post–Civil War settlement of New Home. This settlement started with a school in 1869, which was one of the original tax-supported Benton County schools. This drawing of the schoolhouse is believed to be from sometime between 1880 and 1900. A church that still stands today, along with an adjacent cemetery, was later built across the street from the school. (Cheryl Gregory.)

TERRAIN AND LANDSCAPE. This photograph, taken in the late 1890s, shows the ruggedness of the landscape of Little Sugar Creek Valley. Spring-fed creeks ran through narrow hollows and emptied into Little Sugar Creek. Steep limestone outcroppings lined both sides of the hollows. Because of the cool spring waters, this area was a popular picnicking and recreational ground.

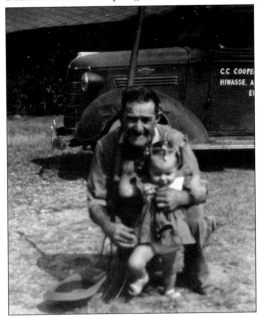

C.C. COOPER. C.C. Cooper bought an 80-acre farm in rural Benton County in 1912. The log cabin he built for his family was saved from demolition by Paul Parish in 1974 and sold in 1997 to Scott and Angie Butler, who donated it to the Bella Vista Historical Society in 2018. It was moved to the Bella Vista Historical Museum in 2019 and has been restored to its early 20th-century appearance (see chapter five for more about the cabin). (Dennis Crabtree.)

Two

THE BAKER AND LINEBARGER RESORTS
1915–1951

In 1909, Mary Baker purchased 159 acres of land at the southern end of the valley of Little Sugar Creek. In 1915, Mary and her husband, William Baker, decided to build a summer resort on Mary's land. A contest was held to decide on a name for the resort. The winner of the contest was Clara Crowder from Bentonville, whose entry was "Bella Vista," which means "beautiful view." The Bakers then built the first dam across Little Sugar Creek to form Lake Bella Vista.

Almost immediately, the Bakers discovered that creating the resort would require more than they were capable of handling. In 1917, they sold the property to the three Linebarger brothers—C.A., F.W., and C.C.—from Texas. The Linebargers had spent part of their young lives in Bentonville and, as experienced land developers, saw the potential in Bella Vista. They immediately began to buy additional parcels of land and plotted out Old Bella Vista. Their main goal was to sell individual lots on which family cottages would be built for summer use. In order to support the cottages, the Linebargers created an electric and water system, several lodges, a dining hall, and a large bathhouse beside the lake. They made numerous improvements to the Bella Vista dam and lake and built an information center next to the highway.

Eventually, the Linebargers created a nine-hole golf course, a swimming pool (the Plunge), a state-of-the-art 65-room hotel (the Sunset), an underground nightclub inside Wonderland Cave, a dance pavilion, and a winery. They also added numerous recreational activities, including horseback riding, fishing, boating, and trails for hiking.

The resort was initially greatly successful, drawing lot-buyers from all the surrounding states as a result of using salesmen such as Dallas Rupe and Terry Peel to call upon wealthy men in large cities. However, the stock market crash of 1929 and the Great Depression took a toll, and by the end of World War II, interest in the resort began to fade. In 1952, Bella Vista Summer Resort was sold to E.L. Keith, which would initiate the next phase of the resort's history.

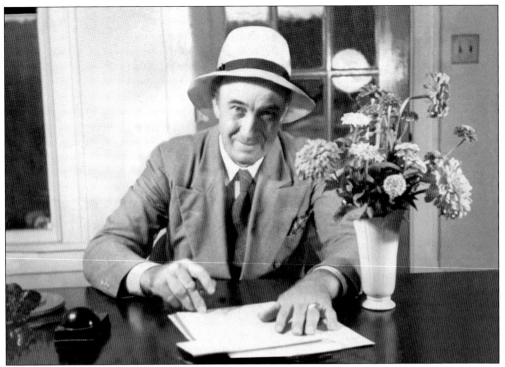

C.A. Linebarger. In 1917, Mary and William Baker sold the Bella Vista Summer Resort to the three Linebarger brothers. The brothers, who had spent part of their youth in Bentonville, were familiar with the beauty of Little Sugar Creek Valley. Pictured here is the youngest of the three brothers, C.A., who became the on-site resident manager after his older brother F.W. got the resort up and running while their other brother C.C. handled the paperwork from their office in Dallas.

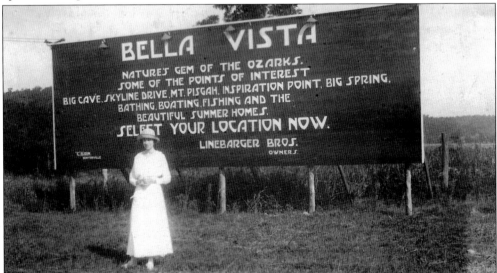

Bella Vista Sign. The Linebarger brothers were masters of advertising. Using signs, brochures, newspaper advertisements, and top-notch salesmen like Terry Peel and Dallas Rupe, they spread the word about the enjoyment of life at the resort. Their objective was to sell lots on which they would build cottages for use during the summer season.

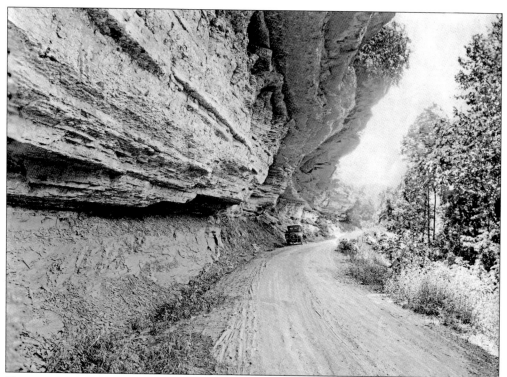

Highway 100 Overhang. One of the difficulties that had to be overcome was access to the resort. Most people would have to arrive by automobile. In 1917, there was not a decent road that went north from Bentonville. F.W. Linebarger worked with city officials, local groups, and other developers to get roads improved and was able to get a graded county road connecting Bentonville with the Missouri state line—this road was named Highway 100. The highway passed under several massive rock overhangs as it wound its way north to the state line. Eventually, this road was paved, straightened, and widened to become today's US Highway 71.

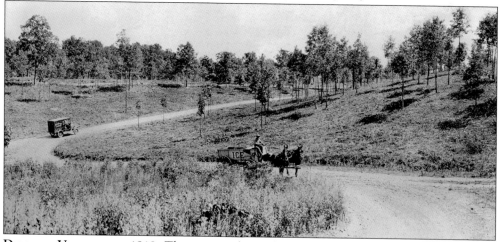

Delivery Vehicles, c. 1918. This picture shows the types of roads that cottage owners and deliverymen had to travel at the summer resort. Local merchants from nearby Bentonville were appreciative of the business they got from the resort. Note the diversity of transportation methods used at that time, including the horse-drawn ice cart and the motorized laundry truck.

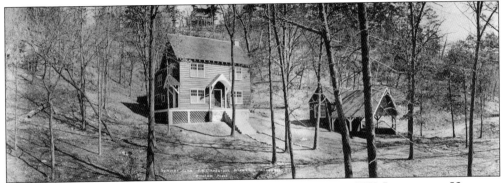

F.W. LINEBARGER HOME.
F.W. Linebarger built a
genuinely nice home at the
resort in the early 1920s on
the north side of the stream
running from Big Spring.
Only the foundation of this
structure remains today.
Note the cottage just above
the home. This cottage
is located near what was
(and still is) referred to
as "Inspiration Point."

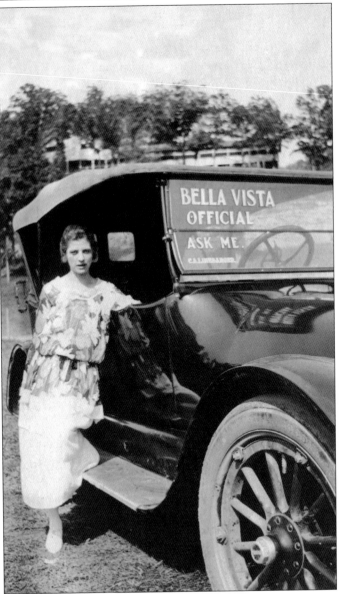

**BELLA VISTA HOSTESS
CARMEN PATTERSON.** One
of the Linebargers' sales
efforts involved hostesses
like Patterson arriving in
marked vehicles to meet
prospective buyers at the
train station in Rogers and
drive them to the resort.
The job of the hostess was
to make sure the interested
parties would be aware of
all that Bella Vista Summer
Resort had to offer, with
the hope that the visitors
would purchase a lot.

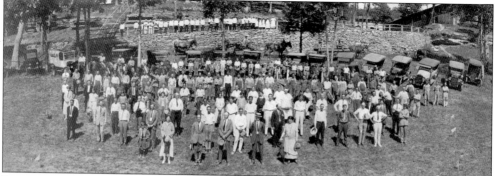

Bella Vista Summer Resort Staff, 1921. With the success of the early years of the resort, the Linebargers had to build a competent and friendly staff. This photograph shows all of the staff members during the 1921 summer season. The three Linebarger brothers are front and center in the picture. C.A. Linebarger Jr., who was born in 1914, is the small boy in the first row. Note the large group of Black employees standing on the stone wall in the background. A portion of the original stone wall shown here still stands today at the base of Skyline Drive.

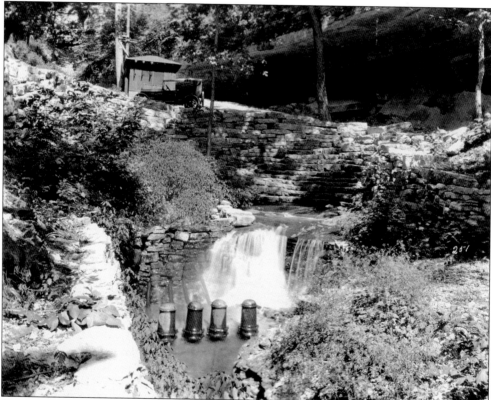

Hydraulic Rams. One of the first problems that the Linebargers had to overcome was how to provide water for the resort. This was solved through the installation of hydraulic rams at Big Spring. With a water flow from the spring of over 500 gallons per minute, the rams pumped water to three large water tanks—two on the east side of the resort, one on the west side—which then, using gravity, served all of the resort's buildings.

C.A. LINEBARGER JR. C.A. Linebarger Jr. is pictured in 1930 or 1931 while he was attending Culver Military Academy in Culver, Indiana. C.A. Jr. obtained a law degree from Cumberland University in Lebanon, Tennessee, and was admitted to the Arkansas bar in 1934. After completing his education, he began assisting his father, C.A. Linebarger Sr., in management of the day-to-day operations of the Bella Vista Summer Resort. When C.A. Sr. was away, management fell to C.A. Jr. and his wife, Florence.

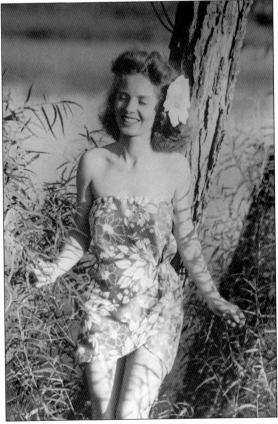

FLORENCE LINEBARGER. Florence married C.A. Linebarger Jr. in 1935 and began working with him at the Bella Vista Summer Resort. As a child, she was known for how much she liked Coca-Cola, earning her the nickname of "Cokie." In this photograph taken by Lillian Green in 1938, Cokie is modeling an outfit that was designed and made by Green.

WHITEY MAY. One of the key members of the Linebargers' staff was foreman W.T. "Whitey" May, shown here on the right. May started working for the resort in 1924. He was the muscle that made Bella Vista Summer Resort a success, as he worked year-round. He kept the water and electrical systems working, repaired flood damage, handled repairs and construction work, fought fires, and responded to the day-to-day needs of the cottage-owners. He also spent each winter doing upkeep and maintenance on the cottages and buildings at the resort.

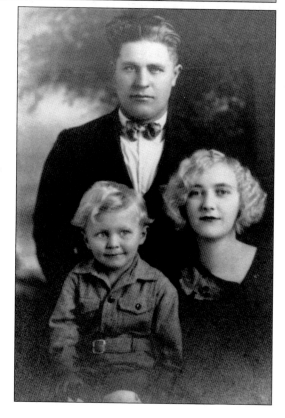

GLADYS MAY. Gladys May, the wife of Whitey May, is pictured with her husband and their son W.T. May Jr. She and Whitey also had a daughter, "Connee" May Norton Waddell. Originally from Oklahoma, Gladys married Whitey in 1924, and they started working at the resort that same year. She was not only Whitey's partner in marriage but also in working full-time at the resort until 1942. She supervised dances at the pavilion and sold tickets at Wonderland Cave.

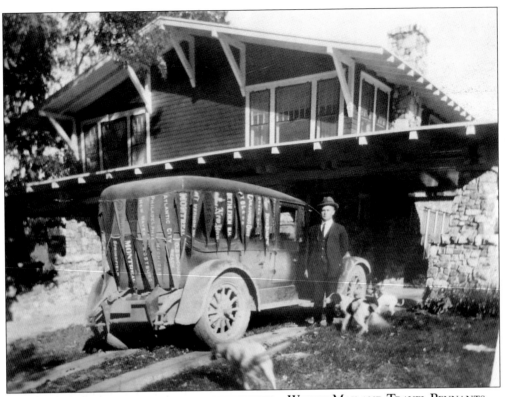

WHITEY MAY AND TRAVEL PENNANTS. Among Whitey May's responsibilities was serving as a chauffeur for C.A. Linebarger. This photograph was taken in front of the Linebargers' "Town House" in Bentonville upon their return from a trip to the eastern United States and Canada. Note the travel pennants hanging from the car—displaying pennants was a common practice in the 1920s to show the places that people had visited.

CONSTANCE "CONNEE" MAY AND ROSEANNE "SALLY" MATOFSKY. Connee (left) is the daughter of Gladys and Whitey May. Born in 1929, she grew up living at the resort. Her stories of life and adventures with her friend Sally are compiled in the book *Sally and Me*. While Constance and her older brother W.T. Jr. had to work at the resort during the summer, there was still plenty of time for them to enjoy the activities that were cornerstones of the resort, like swimming, horseback riding, exploring caves, and playing games.

VALLEY VIEW LODGE. One of the first buildings constructed by the Linebargers in 1917 was Valley View Lodge. It was located on Center Mountain above the Lake Bella Vista dam. The lodge had accommodations for about 60 guests in a 30-room lodge and was connected to the dining hall (the building at right) via a spacious glass hallway. The dining hall could seat 175 people. These buildings also housed a barbershop and beauty shop, a newsstand, a telephone and telegraph office, a drugstore, and a gift shop.

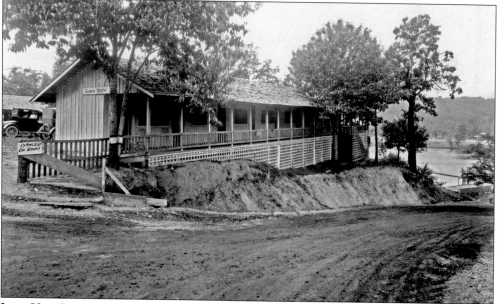

LAKE VIEW LODGE. Constructed shortly after Valley View Lodge, Lake View Lodge was built just to the south across Skyline Drive on Center Mountain. The west side of this U-shaped building overlooked Lake Bella Vista and, like Valley View Lodge, offered only basic accommodations for visitors. This lodge had 40 rooms, with servants' quarters located below the rooms.

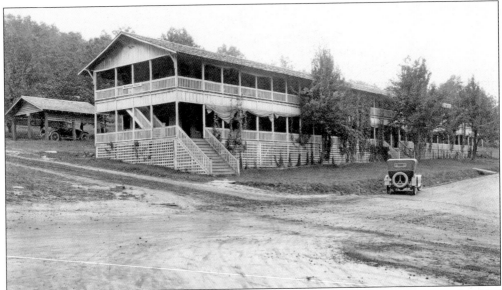

MOUNTAIN VIEW LODGE. Built by the Linebargers in the winter of 1918–1919, this was the third lodge at the resort. It stood just east of and farther up the slope from the Lake View Lodge. This lodge had 52 double and 4 single rooms. The site of the Mountain View and Lake View Lodges is now part of a mobile home subdivision.

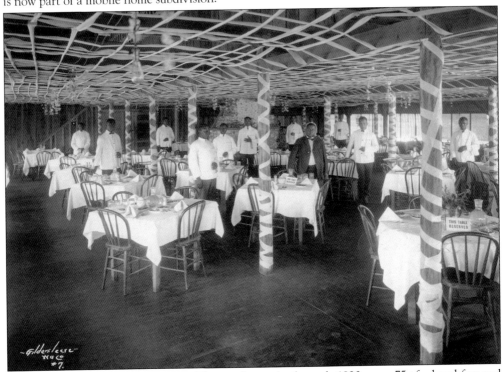

DINING HALL AND WAITERS, 1920s. The meal costs in the early 1920s were 75¢ for breakfast and $1 for lunch and dinner. C.A. Linebarger specifically recruited Black waiters from as far away as Dallas, Little Rock, and Kansas City in order to fill the dining hall with the best workers. They were hired for the summer seasons, and many returned year after year.

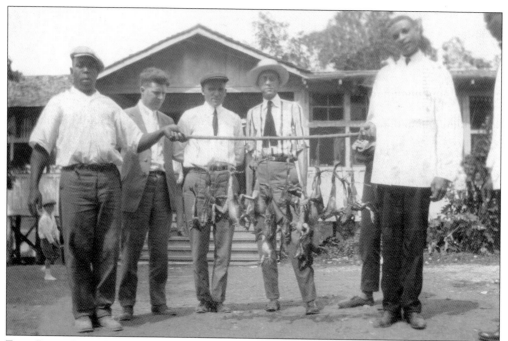

FROG LEGS. One of the best parts of dining at the resort was the preparation of items that could be locally harvested. Among these items were frog legs and fish from Lake Bella Vista or Little Sugar Creek, as well as locally raised chicken, pork, and beef, plus dairy products provided by local farmers.

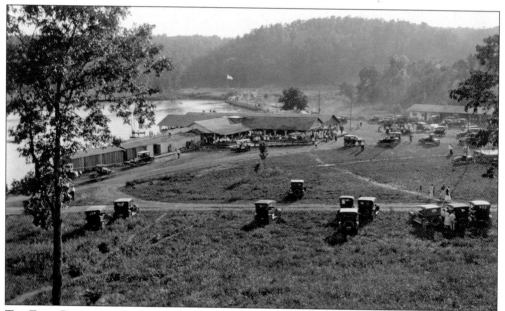

THE FIRST PAVILION. The first pavilion at the resort was constructed in 1917. Also known as "the bathhouse," it was expanded in the 1920s until it evolved into quite a large structure. Located at the northeast corner of Lake Bella Vista, it become the center of recreational activities at the resort. During the day, swimming and boating activities would take place here. In the evening, dance bands would provide the music as the pavilion became a dance floor for the resort's guests.

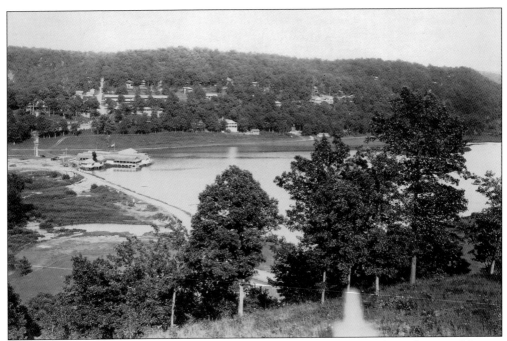

VIEW FROM SUNSET MOUNTAIN, LATE 1920s. This photograph, taken from the top of Sunset Mountain looking east, shows the heart of the Bella Vista resort. At center-left are the greatly expanded Lake Pavilion and the dam. Directly above the pavilion is the Lake View Lodge and the long roof of the Mountain View Lodge. Note how the hillside of Center Mountain is dotted with many of the several hundred cottages that the Linebargers built for summer guests.

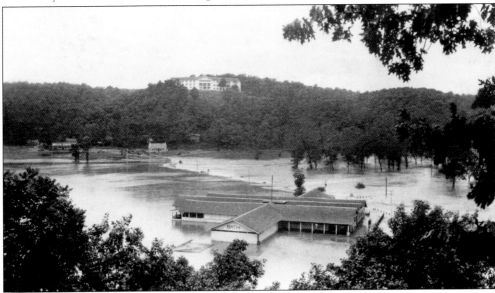

FLOODING OF THE PAVILION. One of the greatest dangers faced by the resort was the flooding of Little Sugar Creek. This 1927 photograph looks west from Center Mountain and shows a half-submerged pavilion. The Lake Bella Vista dam has disappeared completely below the water. The pavilion, damaged by repeated flooding, was eventually destroyed in an accidental fire in 1930 and replaced by a smaller building that was opened in 1931.

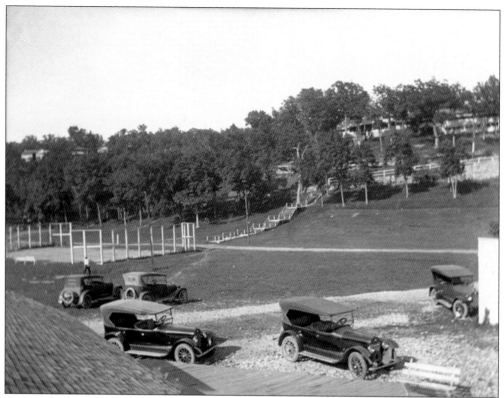

TENNIS COURTS. This photograph from the early 1920s was taken from the top of the bathhouse pavilion looking east toward Center Mountain. It shows the tennis courts on the left that were constructed as part of the recreational opportunities at the resort. Note the long wooden staircase leading up to Skyline Drive and the lodges.

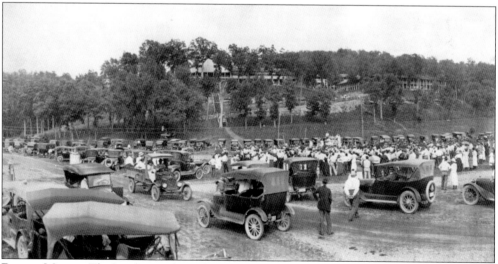

BOXING MATCH. The Linebargers hosted many types of special events to draw people to the resort. Pictured here is a boxing match that was taking place in the parking lot of the pavilion. Other special events included fireworks shows, special dances, parachute jumps, and airplane landings. This view looks east toward the lodges on the hill.

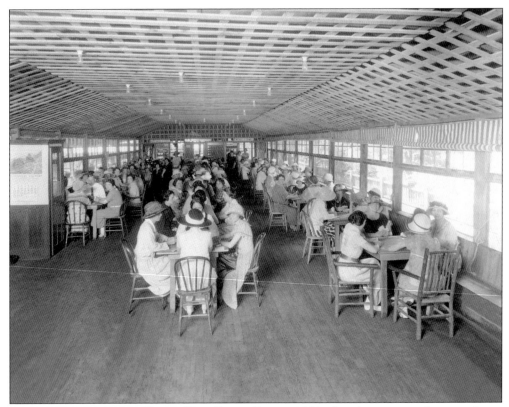

BRIDGE TOURNAMENT IN VALLEY VIEW LODGE LOBBY, 1923. Another activity that was always popular at the resort was playing cards. This photograph shows a bridge tournament being held in the lounge of the Valley View Lodge. Often, it was women and children who spent the summer at the resort while the men of the family commuted from work as their schedules permitted. The women often played cards while the children gallivanted with friends.

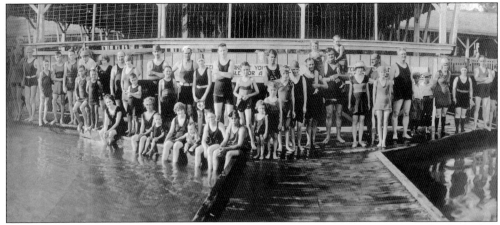

SWIMMERS AT LAKE PAVILION. Until the Linebargers built the big swimming pool, which they opened in 1924, everyone who loved to swim did so in Lake Bella Vista, jumping off the side of the pavilion into the lake. These swimmers posed for a photograph probably around 1920.

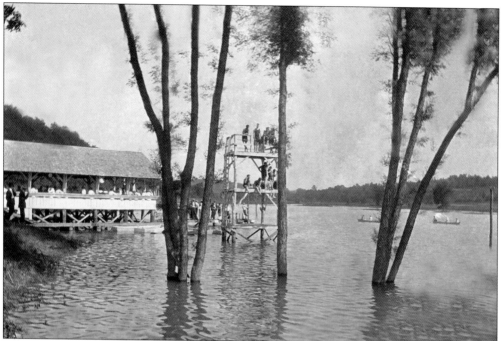

SWIMMERS, A BOARDWALK, AND A DIVING TOWER. The Linebargers greatly encouraged swimming and boating in Lake Bella Vista. Pictured here are two of the improvements made to support these activities. The above photograph from the early 1920s shows the first diving tower, the pavilion, and boaters out on the lake. The below photograph shows a boardwalk, constructed in the early 1920s, that stretched from the pavilion to the far west side of the lake. Note the raised area that allowed boats to pass underneath; this was also used as a diving tower. Because Lake Bella Vista is a man-made lake formed from a fast-moving stream, it was constantly filling with silt. This required the expensive job of dredging it on a regular basis. This led to the 1924 construction of a swimming pool that was named "the Plunge."

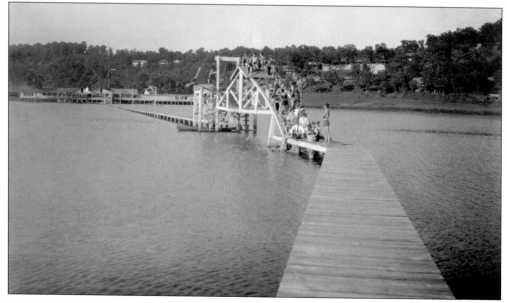

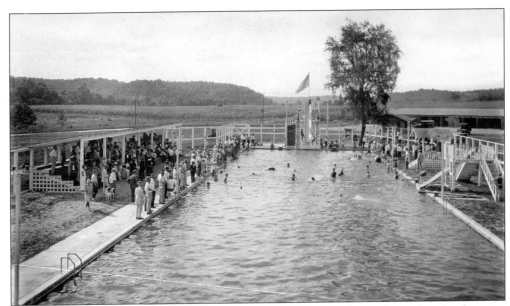

THE PLUNGE, 1928. The Plunge was completed in 1924 to provide another swimming location separate from Lake Bella Vista. It was located just north of the Lake Pavilion. It was advertised as the largest open-air concrete swimming pool in Arkansas. The Plunge was 54 feet wide and 210 feet long and cost more than $20,000 to build. It included slides and a diving tower as well as electric lights for night swimming. This view looks north into Little Sugar Creek Valley.

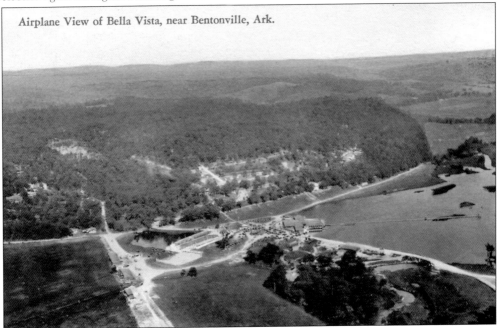

Airplane View of Bella Vista, near Bentonville, Ark.

AERIAL VIEW OF BELLA VISTA SUMMER RESORT. This magnificent aerial view of the resort shows all the major components of the operation. Taken in the mid- to late 1920s and looking east, the photograph shows the full length of Lake Bella Vista and the dam (at right). The pavilion and the Plunge are in the center. Note the "warming pond" beside the Plunge, which was used to warm the water from Big Spring before it was pumped into the Plunge.

THE PLUNGE, 1940S. In the image at right, looking south, note the Army vehicles and tent camp near the upper left corner. Also, note the uniformed soldiers standing near the edge of the pool. The Plunge was unique in that it was filled with water from Big Spring. The pool was emptied, cleaned, and refilled daily.

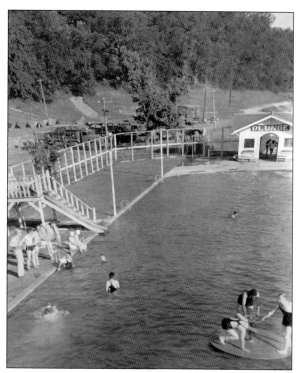

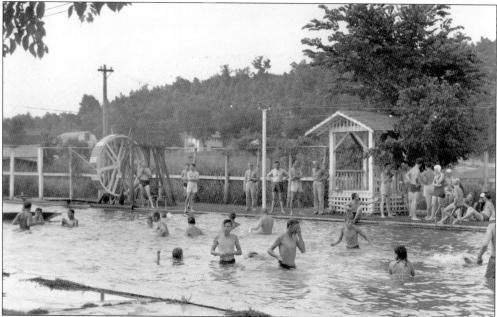

SOLDIERS AT THE PLUNGE, 1940S. There are also uniformed soldiers in this photograph. Camp Crowder (in southern Missouri) and Camp Chaffee (in southern Arkansas) were close enough for soldiers to take recreation time at Bella Vista. The Plunge was one of the most successful features of the resort; in fact, it was so popular that it remained in operation until 1990. The site is now the location of Veterans Memorial Park and the Veterans Memorial Wall. The original sidewalk that ran along the north side of the pool is still visible.

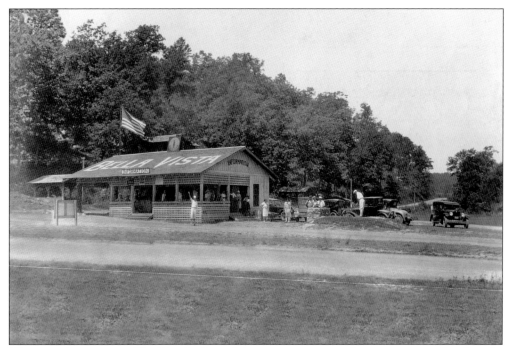

WELCOME CENTER AND TEE NO. 2. One of the many recreational opportunities offered at the resort—and still offered in the City of Bella Vista—was golf. In 1921, the Linebargers opened a nine-hole, par 35, 2,616-yard-long golf course in what had once been cornfields along the west side of Lake Bella Vista parallel to the highway from Bentonville. Pictured here is a golfer getting ready to tee off from tee No. 2, which was located next to the welcome center/pro shop.

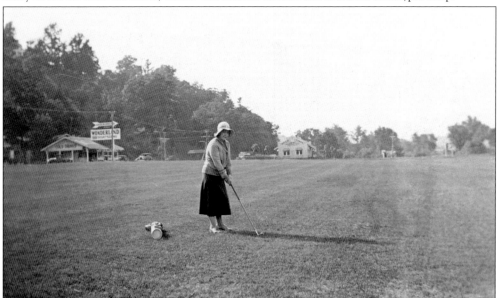

LADY GOLFER, 1928. Golf was a sport that women also took up in its early days. Pictured here is a golfer getting ready to hit toward green No. 9. Note the new welcome center that was combined with the golf pro shop, constructed in 1928 (in the center of the photograph), and the general store (to the left across the highway). Lake Bella Vista is located to the right.

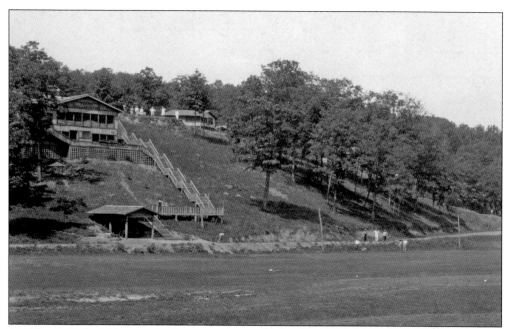

Tee No. 5. One of the most challenging aspects of the course was located on holes 4 and 5. Green No. 4 was not visible from tee No. 4. Golfers had to hit uphill to reach green No. 4. They then moved to tee No. 5, shown in the upper left corner in the above image, and hit back across the highway to green No. 5, which was located in the valley. The course required constant upkeep during the summer. In the off-season, the grounds served other purposes, such as the grazing of livestock. The remnants of tee box No. 5 are still visible on the left as one ascends Louisiana Mountain on Lookout Drive.

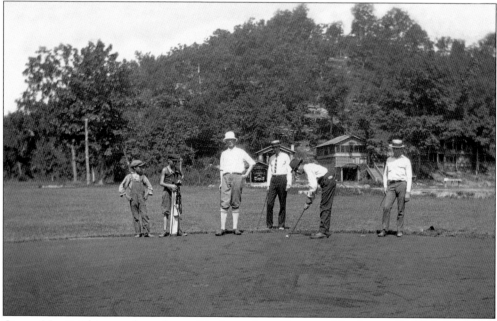

Green No. 9. This was the only par 5 hole on the golf course. The four golfers shown here are putting on the green. Local boys were recruited to serve as caddies.

GREEN NO. 4, C. 1925. This photograph shows golfers on green No. 4 atop Louisiana Mountain. The view is looking southeast. The greens were constructed of fine river sand mixed with motor oil. Fees for using the course were $1 per day, $5 per week, $10 per month, or $15 for the summer season.

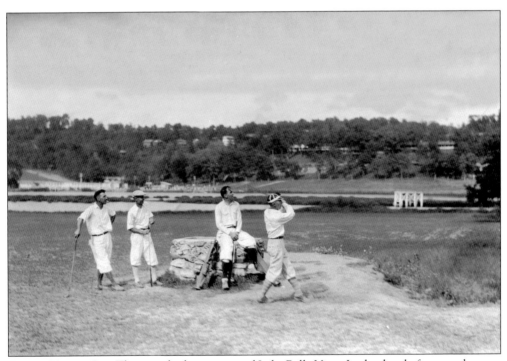

GOLFER TEEING OFF. This view looks east toward Lake Bella Vista. In the days before wooden tees were widely used, each tee box had a container of sand and a pail of water alongside it. Eventually, structures were built with one side holding water and the other sand. Each golfer would take a handful of sand, wet it in the water, and make their own tee using the wet sand.

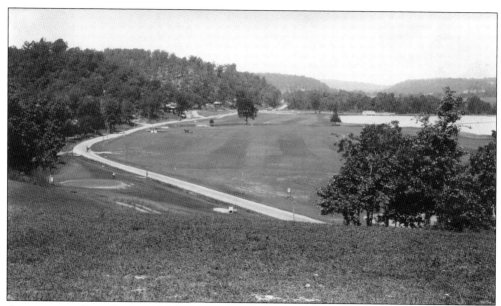

AIRPLANE ON GOLF COURSE. In the early days of aviation, the golf course served more than one purpose—it was also used as a landing strip for airplanes. In the c. 1925 photograph above, taken from green No. 4 and looking north, a plane is sitting on the course in the top left corner near the highway. Green No. 3 and tee No. 4 are visible in the lower left corner. Lake Bella Vista is in the top right corner. The below photograph is a close-up of a Curtiss JN-4 "Jenny" biplane parked on the golf course in the early 1920s. Thousands of Jennys were produced as training aircraft for the US Army during World War I. Many were sold after the war and became the anchors of US civilian aviation and barnstorming. The Linebargers used aircraft to stage events, including parachute jumps and airplane rides, for guests and visitors. They also named the golf course the Bella Vista Airport.

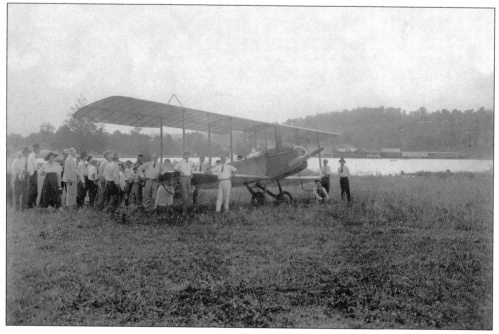

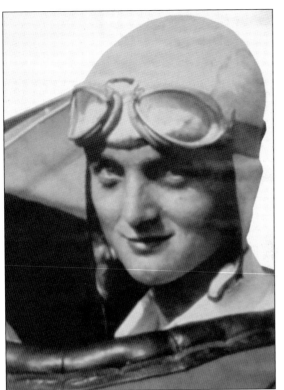

LOUISE THADEN AND THADEN FIELD SIGN. One of the pilots who occasionally landed on the golf course was Louise Thaden of Bentonville. As one of the world's first female pilots, Thaden became a famous aviator and a good friend of Amelia Earhart. Her pilot's license was signed by Orville Wright. As she was landing at the resort in 1929, such a large crowd had gathered that she had to circle the field numerous times to get them to give her room to land. She finally landed with only about 20 feet to spare. In 1936, Thaden became the first woman to win the Vincent Bendix Trophy. She completed the transcontinental race from New York City to Los Angeles in 14 hours and 55 minutes. She was also one of the first advocates for women to serve in combat as fighter pilots. The Bentonville Municipal Airport–Louise M. Thaden Field is named in her honor.

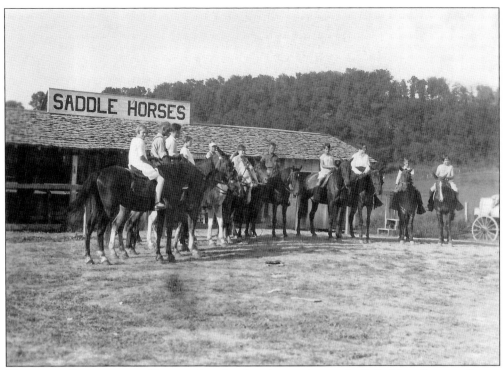

HORSEBACK RIDING AT THE RESORT. Another favorite pastime at the Bella Vista Summer Resort was horseback riding. In the c. 1925 picture above, a group of riders is heading out on the trail. Several miles of trails wound through the hollows and up and down the hillsides of the resort. The first stable barn was located near the base of Center Mountain. The below image shows riders on the road/trail system. Horseback riding remained an activity through the Keith era in the 1950s and the Cooper era that started in the 1960s. It did not end until the last stable barn was torn down in 2006 to make room for Cooper Elementary School.

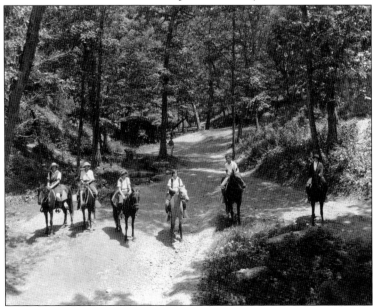

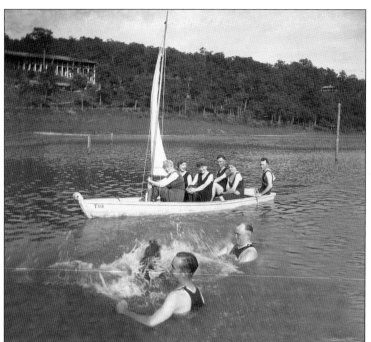

SAILBOATERS, 1920s. This photograph shows boaters on Lake Bella Vista. Canoes were also popular at the time. Years later, other types of boating became common, including paddleboats and, eventually, motorboats pulling water-skiers. Today, only kayaking and canoeing are allowed on the lake, and the lake's main purpose is to serve as a scenic centerpiece for the walking trail that encircles it.

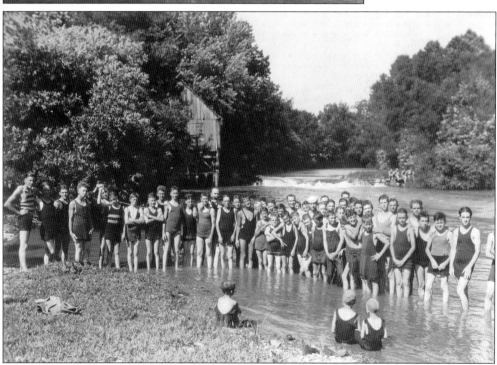

BOY SCOUTS AT LITTLE SUGAR CREEK, 1920s. Over the years, many people enjoyed activities along Little Sugar Creek above and below the dam that formed Lake Bella Vista. These Boy Scouts are pictured at their camp downstream from the resort. Note Little Sugar Creek in its free-flowing appearance. The stream was dotted with small water-powered sawmills and gristmills. These mills provided much of the finished lumber and grain for the resort.

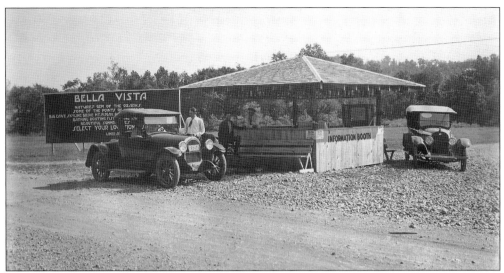

First Welcome Center, c. 1917. This photograph shows Bella Vista's first welcome center/information booth. It was located along the highway at the west end of the Lake Bella Vista dam. The sign urges potential lot-buyers to "select their locations." Potential buyers came from surrounding states, including Texas, Oklahoma, Louisiana, and Kansas, and several lots were purchased by members of the Osage Nation. The discovery of oil on the Osage homeland near Tulsa, Oklahoma, had made them some of the richest people in the country, although some lost that money to "guardians" who were allowed by the courts to oversee their finances.

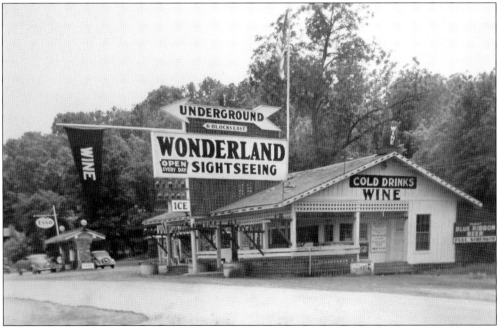

Store and Gas Station. Pictured here is the general store and gas station in the mid-to-late 1930s. This structure stood across the highway from the Linebarger welcome center. Note the large sign for Wonderland Cave, which had become a major tourist destination by this time. Also note the "WINE" sign on the side of the building; soon after Prohibition ended in 1933, C.A. Linebarger created a winery and sold the wine at the resort and throughout the area.

45

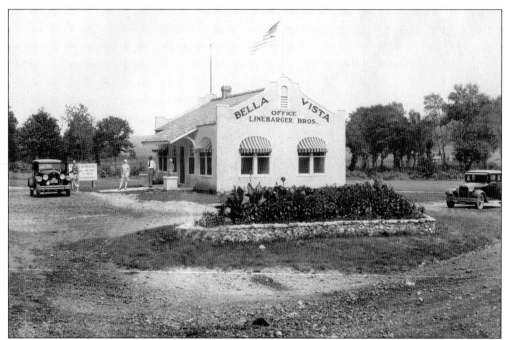

C.A. Linebarger's Office. This welcome center also served as C.A. Linebarger's main office building and was completed in 1928, replacing the earlier wood structure that stood at the west end of Lake Bella Vista dam. Lots at the Bella Vista Summer Resort sold for $300 to $750 depending on location. An article in the *Bella Vista Breezes* from June 1, 1927, refers to three construction crews having built 35 new cottages the previous winter for an average price of $2,500.

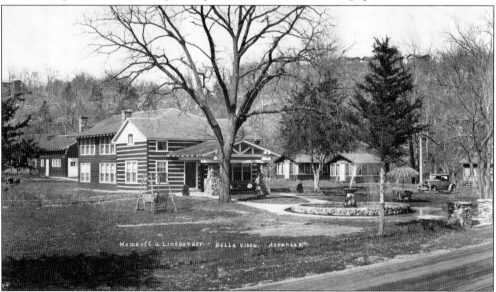

C.A. Linebarger Home, Hale Log House. In 1926, C.A. Linebarger made the 1853 Hale Log House his home. He first moved the house several feet southwest to be farther away from Highway 100. He then modernized and expanded the home. The garage at the rear of the home was built in 1928. Linebarger decided to convert the garage into a winery, which he did in 1935. The small buildings to the right of the home are rental units used by short-term guests.

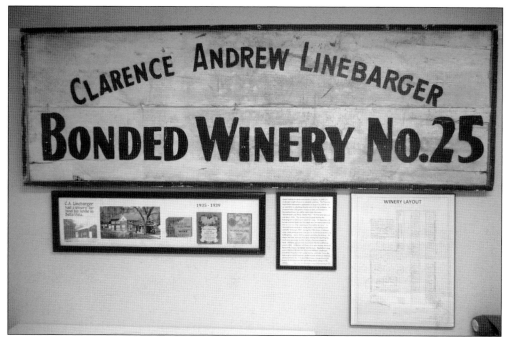

Winery Sign (above) and Belle of Bella Vista Wine Label (below). After the end of Prohibition in 1933, C.A. Linebarger, always looking for additional ways to increase his income, turned the garage at the back of his home into a winery. He first had to acquire a license—the 25th in the state—from the US Treasury Department. In 1935, he produced his first vintage of 1,513 gallons and stored it at Wonderland Cave. It was marketed under the names Wonderland Wine and Belle of Bella Vista; one of the labels is shown below. The wine went on sale to the public in May 1936. It was a huge success. By 1937, C.A. had increased annual production to 4,098 gallons. The wine was served at all the Bella Vista Summer Resort locations and sold to vendors in the surrounding area. By 1938, Linebarger found that the winery was requiring too much effort; he stopped all wine production in 1939 but continued selling the last of his supply until 1945.

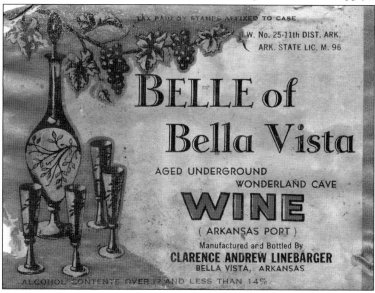

PLAYING CARDS IN THE LINEBARGERS' FRONT YARD, 1927. The Linebarger home was always an active place for resort guests. This photograph shows a group of women in the front yard. Bridge tournaments and other card games were a staple activity at the resort. The view looks east toward the golf course and Lake Bella Vista. In the 1950s, the C.A. Linebarger Jr. family moved into the home, which became the favorite playground of C.A.'s daughter Carole Linebarger and her two sisters. Carole later served as the longtime president of the Bella Vista Historical Society.

SHUTTLE SERVICE BUS. The shuttle bus is pictured in front of the Linebarger home. The shuttle was provided to transport resort guests back and forth from the train station in Rogers. One of the unique aspects of the resort was that some families would spend the entire summer there, often with a chauffeur and the family car. The man of the family would use the shuttle to return to work during the week and come back just for the weekends (or however often he could make it).

ROYAL FERRIS COTTAGE.
The heart of Bella Vista
Summer Resort was the
family cottages. Pictured
here is the Royal Ferris
cottage. This cottage was
built at a cost of $400 in
1924. In most cases, only
the last name was placed on
the cottage, but because the
Ferris family owned several
cottages on Louisiana
Mountain, Royal added his
first name. His nephew F.A.
Ferris had his cottage built
in 1925 next to the golf
course tee No. 5 for $900.
The Ferrises were successful
bankers and businessmen
from Dallas, Texas.

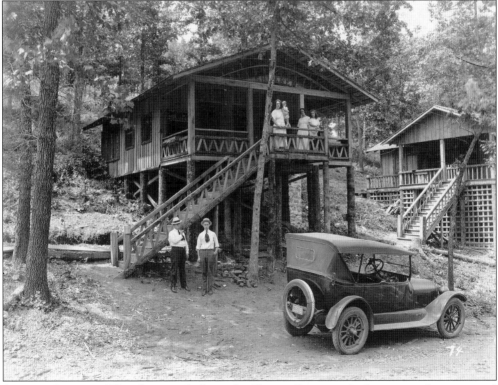

SHEARER COTTAGE. This photograph shows the Shearer Cottage, which was one of an estimated 350 built by the Linebargers' construction crews. It was built in 1920 at a cost of $600. Louis Allgewahr Shearer was from Arkansas City, Kansas, where he was a successful contractor. He was a typical cottage owner—the head of a wealthy family that could afford a second home. They often brought household staff with them who were quartered on the lower level of the cottage if the cottage was built on a slope.

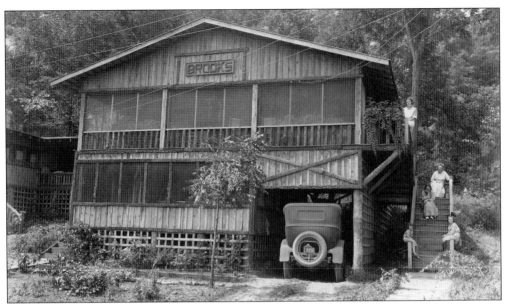

BROOKS COTTAGE. This is the cottage of Stratton D. Brooks, who became president of the University of Oklahoma at Norman in 1912. The cottage was built before 1923 at a cost of $2,258. It stood at the base of Suits Us Mountain across the highway from Lake Bella Vista behind today's Arkansas Welcome Center. Standing at the top of the steps is Lillian Green, a summer employee of the Brooks family. Green later became a well-known professional photographer.

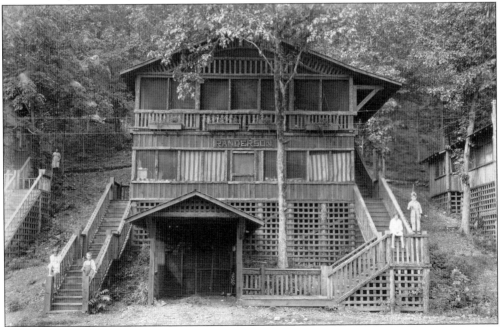

RANDERSON COTTAGE. The summer cottage of R.S. Randerson of Oklahoma City, Oklahoma, was built in 1924 for $900. It stood at the base of Suits Us Mountain just south of the present Arkansas Welcome Center. Many of these cottages were built with all the modern conveniences of the time, including electricity, hot and cold running water, refrigerators, and a garage for the family car. Of the 350 cottages built, only about a dozen remained in 2020. This is one that still stands.

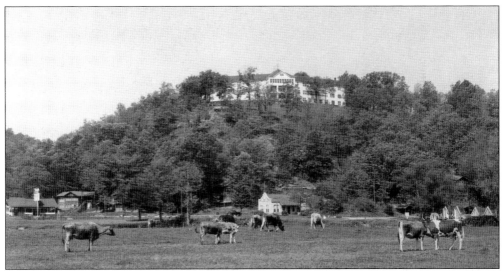

THE SUNSET HOTEL. The Sunset Hotel opened in 1929 on the top of Sunset Mountain on the west side of the highway overlooking Lake Bella Vista. It had 65 rooms, each with a private bath or a bath between two rooms to form a suite. In 1932, Harry and Bess Truman were guests at the hotel with their daughter Margaret, who enjoyed playing the hotel's piano during that visit. The bands the Linebargers booked for the summer season also stayed at the hotel. Local residents also enjoyed dancing and dinner at the hotel. C.A. Linebarger and his wife, Regina "Ray," began staying there when they rented their log house to summer guests. In the above photograph, note the cattle grazing on the golf course. During the off-season, the Linebargers would attempt to find other ways for their properties to generate revenue. The below photograph shows the west entrance and parking lot of the hotel during a large event in 1930.

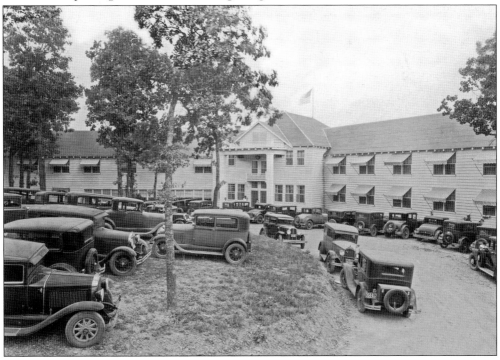

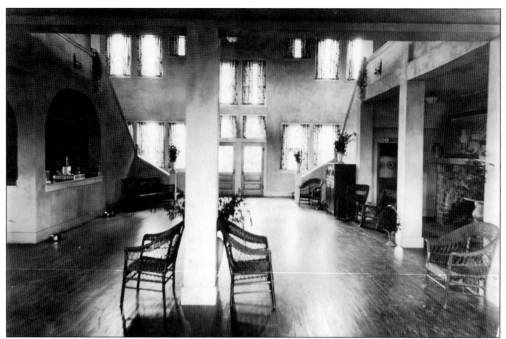

SUNSET HOTEL LOBBY. Very few pictures of the interior of the Sunset Hotel have survived. These images show the main lobby of the hotel. The above photograph is looking west toward the main entrance, and the one below is looking east toward the verandas and Lake Bella Vista. The hotel was designed by architect A.O. Clark from Rogers, Arkansas. It was 276 feet long and three stories tall. Besides the guest rooms, the hotel contained a dining room, a spacious parlor, writing and lounging rooms, and large colonial porches that overlooked the entire resort and Little Sugar Creek Valley. It also included a children's playground and 15 acres of grounds that were designed for walking trails. A long wooden staircase extended from the hotel down to Highway 100 across from Lake Bella Vista. This magnificent building served several different purposes (these will be discussed in chapters three and four) before it was finally destroyed by arson in 1999.

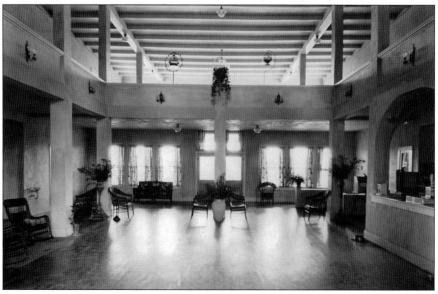

FERN WILLIAMS. Fern Williams began working at the Bella Vista Summer Resort in 1930. She became manager of the Sunset Hotel around 1939 or 1940. In 1941, the hotel staff, consisting of more than 25 people, was the largest in the hotel's history. Women were important to the success of the resort, including Irma Nott-Magruder, who managed the Dance Pavilion for several years starting in 1925.

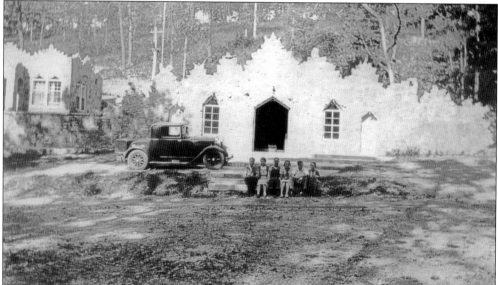

WONDERLAND CAVE ENTRANCE. After C.A. Linebarger and his wife visited a Paris nightclub in a basement decorated to look like a cave in the fall of 1929, he decided to convert Big Cave in Bella Vista to an underground nightclub, which opened on March 1, 1930. The enhanced entrance shown here was made of mortar and stone and added in early 1932. The cave, which had always been a tourist attraction, continued to offer tours during the summer months.

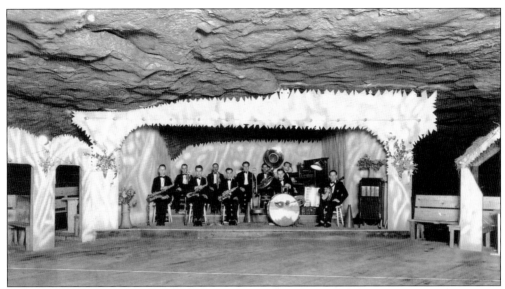

BAND IN WONDERLAND CAVE. This photograph shows an unidentified band inside Wonderland Cave sometime in the early 1930s. In order to create the nightclub, C.A. Linebarger had his work crews, under the direction of Whitey May, install stairs and walks connecting the entrance with the dance floor. The crews also installed electricity, a wooden dance floor, booths for customers, a bandstand, and a snack bar. Wonderland Cave opened to 400 guests on March 1, 1930.

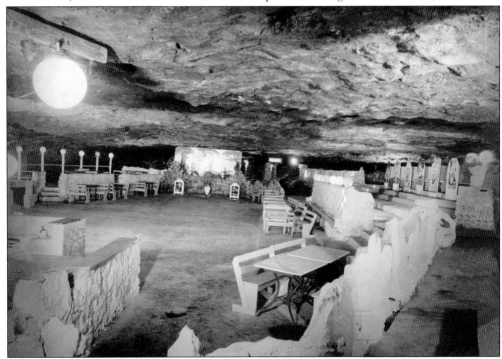

WONDERLAND DANCE FLOOR. In this image, the bandstand is in the background facing toward the dance floor. The Linebargers chose different themes for the nightclub over many years. Here, circus clown characters are visible at the ends of each booth on the right. The cave remained at a constant 62 degrees with 100 percent humidity.

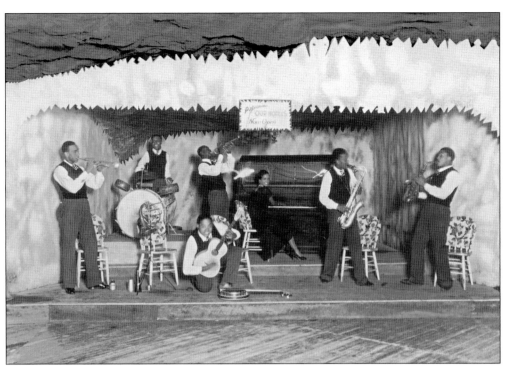

CLARENCE LOVE AND HIS AFRICANS. For opening night in Wonderland Cave on March 1, 1930, C.A. Linebarger hired Clarence Love and His Africans. This orchestra returned six weeks later to another great turnout. Originally from Oklahoma, Love grew up in Kansas City, where he lived and played music for many years. He eventually moved back to Oklahoma, where he opened his own club. He died in Tulsa in 1998.

AERIAL VIEW, EARLY 1930S. This aerial view shows the Bella Vista Summer Resort and Little Sugar Creek Valley. The view looks north down the valley. In the center foreground is the new Dance Pavilion and deck built out over Lake Bella Vista. The Plunge swimming pool is just above the pavilion. The first lodges on Center Mountain are to the lower right. The welcome center, which also served as C.A. Linebarger's office, is in the lower left at the west end of the dam. (Grabill Photography.)

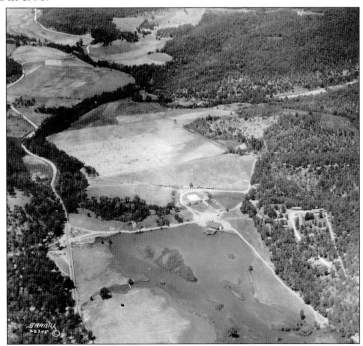

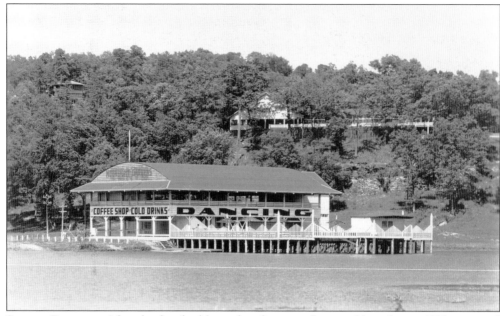

SECOND PAVILION. After the first bathhouse/pavilion was destroyed by a fire in 1930, a second building was constructed at the same site and opened for the 1931 season. The building measured 60 by 40 feet and was two stories high. The first floor contained a soda fountain, coffee shop, shooting gallery, and restrooms. The second floor was a large ballroom that was later named Moonlight Gardens. This view looks east toward Center Mountain and the lodges.

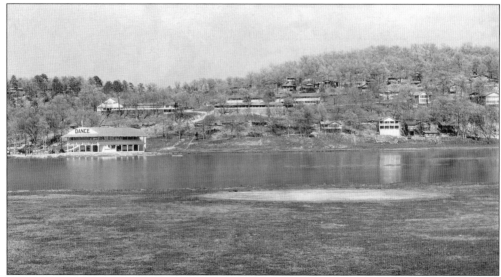

LOOKING EAST TOWARD THE DANCE PAVILION. This picture shows the new Dance Pavilion shortly after its completion in 1930–1931. Directly above it are the lodges on Center Mountain. On the right are many of the resort's private cottages. Unfortunately, many of these cottages were lost to neglect and fire over the years. The foundations and fireplaces of some of them are still visible today along the walking trail that circles Lake Bella Vista.

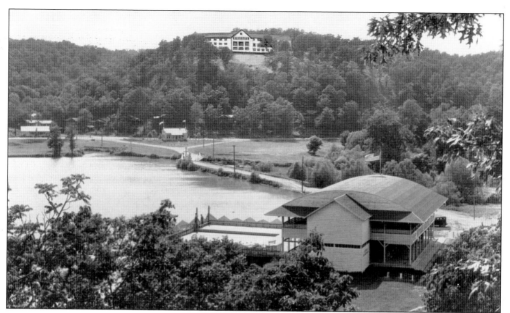

The Dance Pavilion and Sunset Hotel. This view looks west from Center Mountain in the mid-1930s. It shows the pavilion with the new deck that was added after the initial construction and built out over Lake Bella Vista. This pavilion was specifically designed to be more open on the first floor in hopes that damage from floodwaters, which often affected the first pavilion, would be minimal. The Sunset Hotel is visible on the hill in the background.

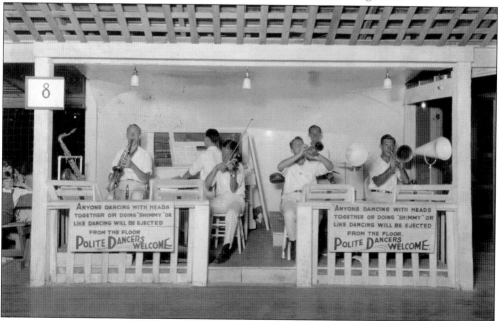

Band at Dance Pavilion. This photograph shows an unidentified band playing at the Dance Pavilion in the 1930s. Note the warning signs posted on the bandstand that told dancers how to behave—or else they would be ejected. Music was a vital part of the day-to-day experience at the resort, especially in the evenings. Some bands were hired by contract through the Music Corporation of America, which was based in Chicago. (Fred Gildersleeve.)

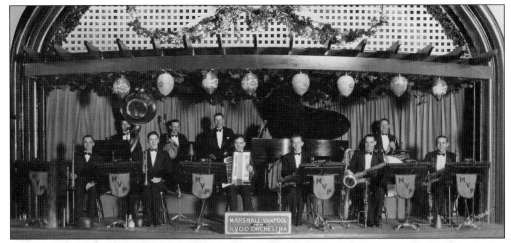

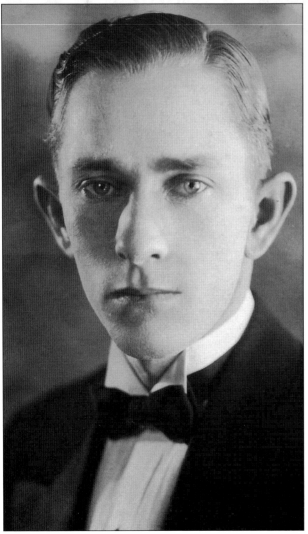

MARSHALL VAN POOL AND HIS KVOO ORCHESTRA. One of the most popular bands at the resort in the 1920s and 1930s was Marshall Van Pool and his KVOO Orchestra. Van Pool was the leader of this orchestra from 1923 to 1941. His 10-piece orchestra was a favorite of resort guests and attracted people from the surrounding communities. The June 12, 1928, *Bella Vista Breezes* reported, "Marshall Van Pool and his superb orchestra opened the season at Bella Vista on Friday night. Over 300 persons enjoyed the initial dance which will be a nightly affair, except Sunday, until the close of the season." "KVOO" refers to a radio station located in Tulsa, Oklahoma, that was one of the band's sponsors. The station had its own 13-member staff orchestra and 30 different musical groups performing live each week.

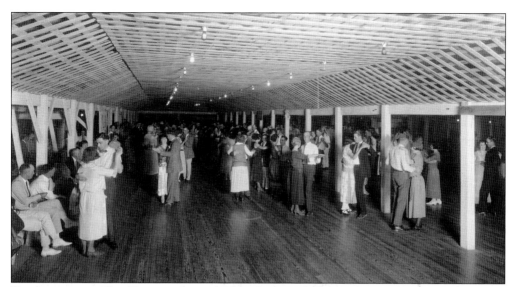

DANCING AT THE NEW PAVILION, 1930s. This photograph shows guests enjoying a dance on the second floor of the new Dance Pavilion. Dancing was a primary activity during the Linebarger period. Almost every day, and sometimes more than once a day, guests could find a band playing at the pavilion (aka Moonlight Gardens) or the Sunset Hotel, in the lodges, or at Wonderland Cave. Dance lessons also were offered as part of the summer activities.

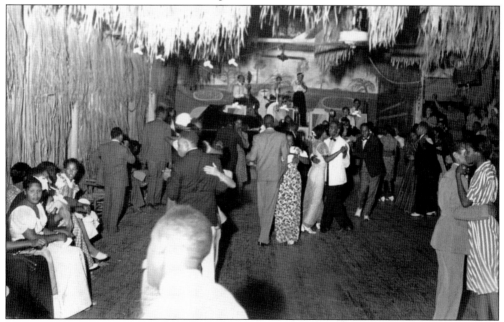

EMANCIPATION DANCES. In the 1920s, 1930s, and 1940s, segregation was in effect across the United States, and the Bella Vista Summer Resort was no exception. It is estimated that during the summer seasons, over 300 Black employees worked at the resort and for cottage owners. They provided the majority of the labor that made the resort successful and worked as chauffeurs, cooks, waiters, laundresses, maids, caregivers, and laborers. This photograph shows dancers at one of the emancipation dances that were held for Black employees and their friends on an annual basis for over 20 years.

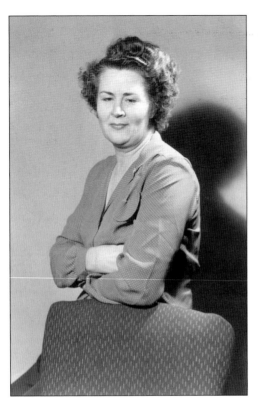

LILLIAN GREEN. Lillian Green was born in Kansas in 1903 to Thomas and Belle Green, who moved to Benton County, Arkansas, when she was a child. As a young woman, she spent her summers working for Bella Vista cottage owner Stratton Brooks, who was a college president and encouraged her to attend college, which she did in Springfield, Missouri. After teaching school for a short time, she came back to Bella Vista in the mid-1920s and began working as C.A. Linebarger's secretarial assistant in 1929.

NADINE LOGSTON. In 1938, Lillian Green took her niece, Nadine Logston (pictured at right with makeup artist Carl Exgill) to the filming location of *Jesse James* in nearby Pineville, Missouri, to get Nadine a part in the movie. Green became fascinated by the work of the still photographers on the set. She was self-taught and became an extraordinarily successful photographer, selling her pictures to regional and national magazines (and at least two of them to jigsaw-puzzle manufacturers). When Green became ill in the 1950s, she moved to Oregon to live with her sister, and she died in 1956.

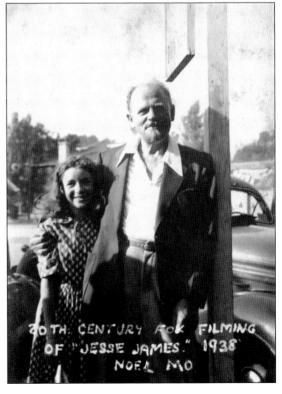

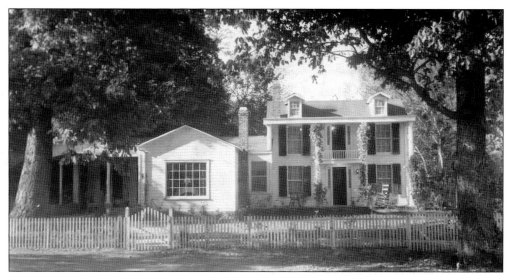

LILLIAN GREEN HOME. When Green became a professional photographer, she added the studio on the right with a pseudo-Southern motif at one-half scale. After Green's death, the home was converted to a convenience store; it was destroyed in a controlled burn in 1987 to make room for a new office/rental complex called Hampton Place.

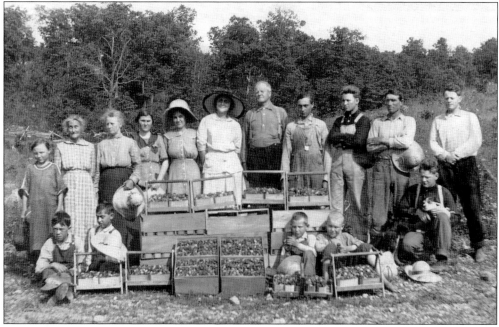

STRAWBERRY CROP HARVEST. Strawberry picking was often a family affair, as was the case with the Hobbs family pictured here in the early 1900s. Strawberries have a short peak time after they are picked, so they need to be transported and sold quickly. When the strawberries were ready to be picked, if schools were not yet out for the summer, the country schools would shut down long enough for students, parents, and teachers to pick them until the harvest was completed.

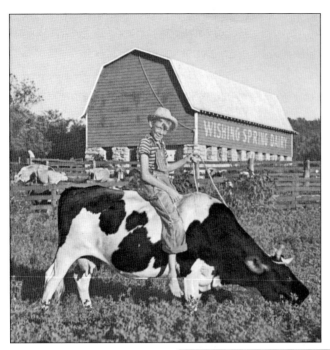

JIMMY HUCKABEE. Jimmy Huckabee is pictured on one of the Linebarger cows in front of the Wishing Spring dairy barn just south of Lake Bella Vista. Jimmy lived with his parents on the ranch on the hill across the highway from the barn. This picture was one of photographer Lillian Green's favorites that she took, and it made the cover of the June 1946 *Rotarian* magazine.

CORN HARVEST. Corn was one of the crops farmers raised in the area that now makes up the City of Bella Vista. Other crops included strawberries, blackberries, green beans, and tomatoes. The valley and its surrounding highlands also helped farmers to provide a supply of beef, chicken, pork, and dairy products for the resort and the region. This 1940s photograph by Lillian Green features the Wayne Snyder family.

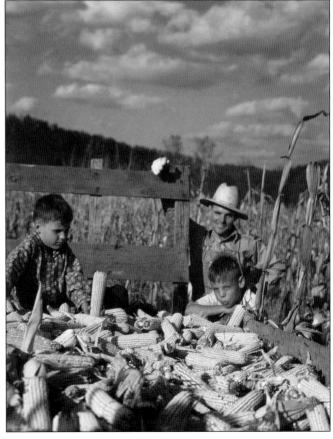

WILMA AND DEAN MOWAN, C. 1948.
This photograph taken by Lillian Green shows Wilma Mowan and her four-year-old brother Dean hauling blackberries in their pails. The Mowans lived in a house along Highway 100 (now US Highway 71) below the Sunset Hotel. Wilma and Dean were favorite subjects of Green and appeared together on the December 1947 cover of *American Poultry Journal*.

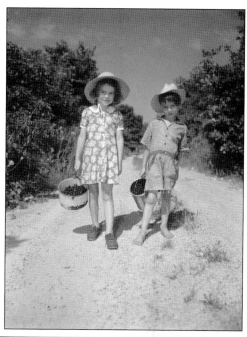

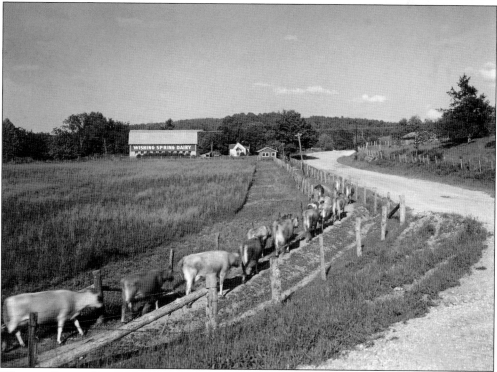

WISHING SPRING DAIRY, 1940S. This photograph by Lillian Green shows the Linebarger cattle headed back to the barn along Benton County Road 40 after spending time in the pasture around Lake Bella Vista. Dredged silt from the lake was later used to raise this pasture out of the flood plain, and it is now the location of a Walgreens. The barn is still standing and is home to the Wishing Spring Art Gallery.

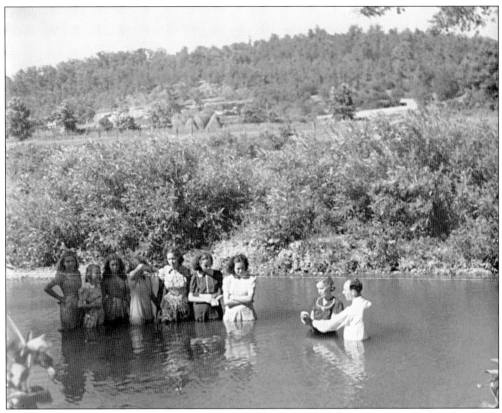

Little Sugar Creek Baptism, Late 1930s. Lillian Green, who grew up on a farm in Little Sugar Creek Valley across the road from Dug Hill church, often made her friends and family the subjects of her pictures. This photograph, taken early in Green's photography career, shows members of her family and some neighbors being baptized in Little Sugar Creek near the family farm. The land where that farm stood is now the northern end of the Kingswood Golf Course.

Young Carole Linebarger Harter. This special photograph taken by Lillian Green is of six-year-old Carole Linebarger. It appeared on the February 1948 cover of *American Poultry Journal*. Carole was the daughter of Florence and C.A. Linebarger Jr. and the granddaughter of C.A. Linebarger Sr. This volume is dedicated to Carole. It is due to her tireless efforts and support that the Bella Vista Historical Society and the Bella Vista Historical Museum exist today. (*American Poultry Journal*.)

Three

THE KEITH RESORT
1952–1963

After purchasing the majority of the Bella Vista Summer Resort for about $56,000 from the Linebargers in 1952, E.L. Keith immediately began to make changes and improvements. The biggest addition was the construction of a dam across Big Spring Creek and the creation of a trout farm. He built a restaurant using the old building that housed the Linebarger headquarters at the west end of the Lake Bella Vista dam. He also built a grocery store at that same location and a small motel for overnight guests. He tore down the old dining hall and lodges located on the hillside east of Lake Bella Vista and built his personal residence there.

Keith rehabilitated the swimming pool with new concrete walls and flooring and added a modern filter and chlorination system. A wading pool was added for children, as well as a small building alongside the pool to be used as a bathhouse and snack bar. He strengthened and raised the Lake Bella Vista dam and dredged the lake, which had nearly filled with silt. He greatly improved the horseback-riding program by adding 40 horses and a three-mile riding trail. He also added a miniature golf course and a golf driving range.

Keith was a strict Baptist who did not approve of dancing, so he converted the second floor of the Lake Pavilion from a dance floor to a roller-skating rink. He made improvements to the Sunset Hotel, which he renamed Sunset Lodge, including a new roof, exterior painting, and new interior fixtures, but after one season of trying to run it as a hotel, in 1953, he turned it over to a Baptist minister who established a short-lived high school named the Baptist Institute of the Ozarks.

The Linebarger influence did not completely disappear from the area. C.A. Linebarger still owned 1,500 acres of land, which included Wishing Spring Dairy, Wonderland Cave, and his private residence. The Keith period ended shortly after a new developer showed up in 1962 with interest in the summer resort in Little Sugar Creek Valley—his name was John A. Cooper Sr.

E.L. KEITH AND LAKE KEITH. E.L Keith got his start as a successful businessman in Borger, Texas. He decided he wanted to retire in Arkansas by buying a resort. There was a small lake in Cave Springs, Arkansas, that he had already enlarged and named Lake Keith; he opened it in 1950. After two successful years in Cave Springs, he heard that Bella Vista Summer Resort was for sale, so he bought it. He sold Lake Keith in 1956. Keith was also a very generous philanthropist who, in 1988, set up a scholarship in his name at Ouachita Baptist University in Arkadelphia, Arkansas, that continues to this day. He also donated a large sum to the Arkansas Sheriffs' Youth Ranch in Batesville for construction of a youth residence named Keith Hall. He made generous donations and helped with the construction of Baptist churches in Cave Springs and Bella Vista.

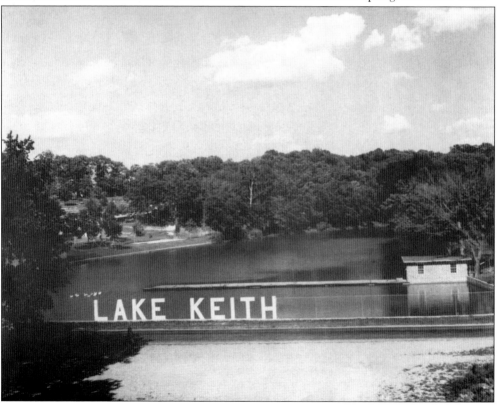

KEITH CHILDREN. This is a photograph of two of E.L. Keith's four sons taken at their home in the late 1930s in Borger, Texas. Adrian (left), born in 1933, is pictured with his brother Gene, born in 1931. As they got older, the boys would work for their dad at his resorts. They worked as lifeguards at the pool, helped with the trout farm, and did whatever else was needed. (Josephine Keith.)

TROUT FARM POOL. This photograph looks upstream toward Big Spring from the small dam E.L. Keith built to form the trout farm on the east side of Lake Bella Vista. He had been successful with his trout hatchery in Cave Springs and decided to replicate that in Bella Vista. The trout farm was one of the most notable activities at the resort in the 1950s and continued for several decades.

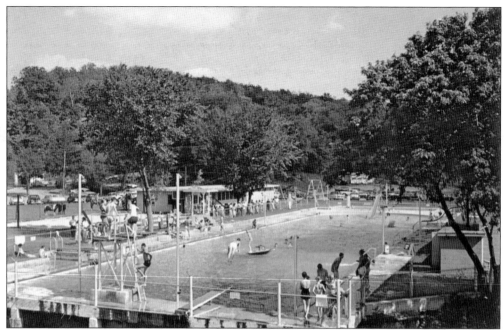

REHABILITATED PLUNGE (ABOVE) AND MINIATURE GOLF COURSE (BELOW). E.L. Keith enlarged the Plunge swimming pool and added a kids' pool, a snack bar, changing rooms, and a miniature golf course beside the pool. In the above photograph from the early 1960s, the horses at center left are getting ready for a trail ride. C.A. Linebarger's granddaughter Carole is in the lower right corner of this photograph with her back to the camera, wearing a black bathing suit. To her right is her sister Ann, and in front of Ann is their friend Ellen Compton. Keith was not interested in golf and chose not to revive the old Linebarger golf course. His two concessions to appeal to golfers were this miniature golf course and a driving range.

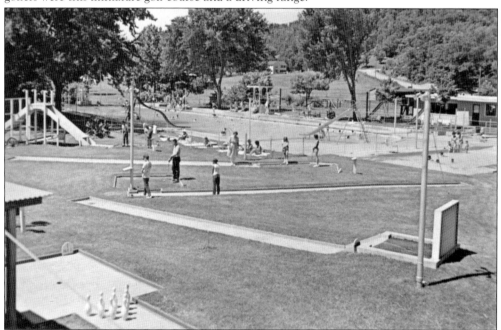

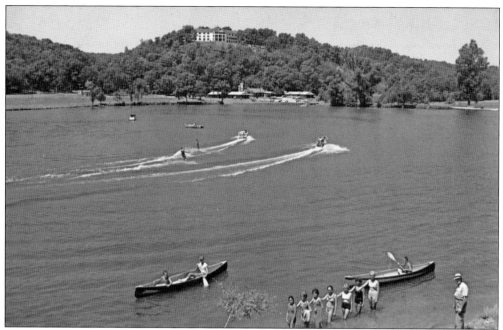

BOATING ON LAKE BELLA VISTA. Water sports were something E.L. Keith endlessly promoted. Here, he is pictured in the lower right corner with a row of pretty girls in their swimsuits. Note the canoes, motorboats, and water-skiers on Lake Bella Vista. This view looks west from the pavilion toward the Sunset Hotel (renamed Sunset Lodge by Keith); along the highway, Keith's motel and restaurant/grocery store are visible.

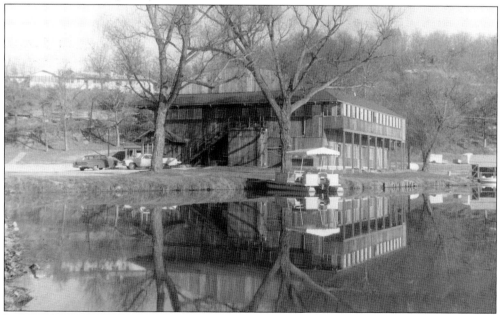

REHABILITATED PAVILION AND E.L. KEITH HOME. When Keith bought the resort from the Linebargers, he enclosed the old Dance Pavilion and replaced the dance floor with a roller-skating rink. The large private residence Keith built in 1954 is visible in the upper left background. Keith was tremendously successful in reinvigorating interest in the Bella Vista Summer Resort.

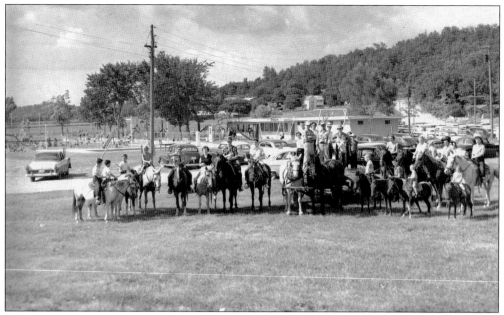

HORSING AROUND. These two photographs show the importance of horseback riding during the E.L. Keith era. In the 1950s photograph above, a large group is getting ready for a trail ride. The view is looking northeast toward the Plunge and snack bar. The farmhouse in the background (directly above the snack bar) was on the Knott farm; this is now the location of Cooper Elementary School. Note the hay wagon in the center of the photograph. Hayrides were also part of the activities offered during this period. Also note, in both pictures, the inclusion of people from all age groups, including the youngest riders on ponies.

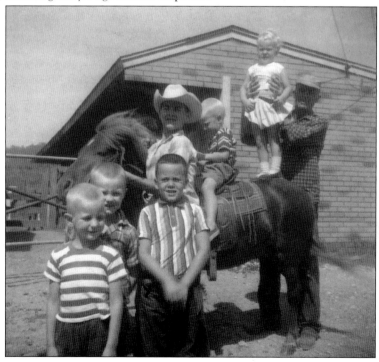

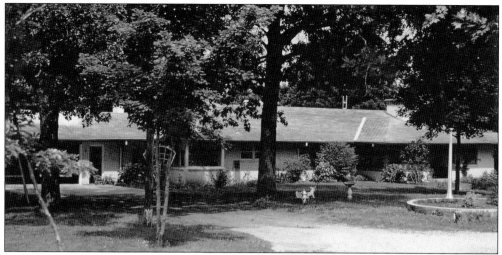

KEITH HOME. E.L. Keith built this magnificent 5,000-plus-square-foot home for himself and his family in 1954 in the location where the dining hall and Valley View Lodge formerly stood on the east side of Lake Bella Vista. Keith's first wife, Ilda, the mother of his four sons, died in 1987. He remarried and continued to live in this home until he died in 1993. E.L.'s son Gene Keith and his wife, Josephine, moved in to help E.L.'s second wife, Annie, care for him a few months before he died. Gene died in 2016, but Josephine and one of their sons still reside here.

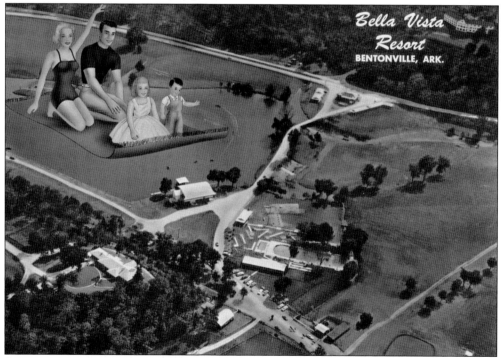

AERIAL POSTCARD OF RESORT, MID-1950S. This photograph shows an oversized postcard used by E.L. Keith for advertising in the mid-1950s. The roof of his large home is shown at lower left. At the time that Keith owned the resort, Bella Vista, due to its rural location, did not have its own mailing address, so all mail intended for Bella Vista had to be addressed to the nearby town of Bentonville.

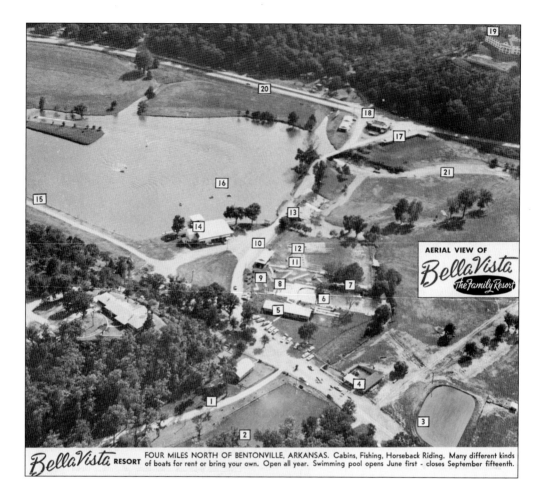

AERIAL VIEW OF
Bella Vista
The Family Resort

Bella Vista RESORT FOUR MILES NORTH OF BENTONVILLE, ARKANSAS. Cabins, Fishing, Horseback Riding. Many different kinds of boats for rent or bring your own. Open all year. Swimming pool opens June first - closes September fifteenth.

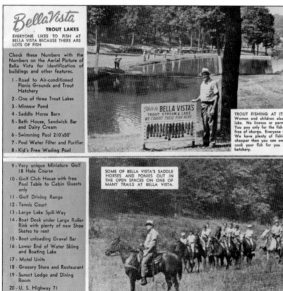

Bella Vista
TROUT LAKES
EVERYONE LIKES TO FISH AT
BELLA VISTA BECAUSE THERE ARE
LOTS OF FISH

Check these Numbers with the
Numbers on the Aerial Picture of
Bella Vista for identification of
buildings and other features.

1 - Road to Air-conditioned
Picnic Grounds and Trout
Hatchery
2 - One of three Trout Lakes
3 - Minnow Pond
4 - Saddle Horse Barn
5 - Bath House, Sandwich Bar
and Dairy Cream
6 - Swimming Pool 210'x50'
7 - Pool Water Filter and Purifier
8 - Kid's Free Wading Pool

9 - Very unique Miniature Golf
18 Hole Course
10 - Golf Club House with free
Pool Table to Cabin Guests
only
11 - Golf Driving Range
12 - Tennis Court
13 - Large Lake Spill-Way
14 - Boat Dock under Large Roller
Rink with plenty of new Shoe
Skates to rent
15 - Boat unloading Gravel Bar
16 - Lower End of Water Skiing
and Boating Lake
17 - Motel Units
18 - Grocery Store and Restaurant
19 - Sunset Lodge and Dining
Room
20 - U. S. Highway 71
21 - Continuation of Sugar Creek

AERIAL VIEW AND ADVERTISING BROCHURE DETAILS. The above image features a brochure that used the same image shown on the bottom of page 71. Many of E.L. Keith's improvements are visible here, including the main trout pond (2), the minnow pond (3), the saddle barn (4), the miniature golf course (9), the driving range (11), the pavilion and roller rink (14), the motel (17), and the grocery store and restaurant (18). Guests could picnic for free and try their luck at fishing, only having to pay if they caught a fish. Guests could choose to either take them home or have them cooked and served in the restaurant. It is estimated that Keith spent almost $300,000 on improvements to the resort.

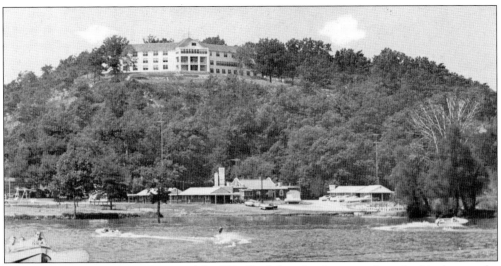

KEITH HOTEL AND SUNSET LODGE. After E.L. Keith bought the resort from the Linebargers, he enlarged their sales office at the west end of the dam into a restaurant/grocery store, which is shown in the center of this photograph. To the right of that building is the new motel. In the foreground are several motorboats on Lake Bella Vista pulling water-skiers. Rising in the background is the old Sunset Hotel, which Keith renamed the Sunset Lodge.

BAPTIST INSTITUTE OF THE OZARKS YEARBOOK. For the first year he owned the resort, E.L. Keith attempted to maintain the Sunset Hotel as a hotel. When this was not successful, he turned it over to a Baptist minister, Rev. North East West, for use as a high school. Named the Baptist Institute of the Ozarks, it opened on September 6, 1953. The Institute was short-lived; it closed in 1959. A page from the final yearbook is pictured here.

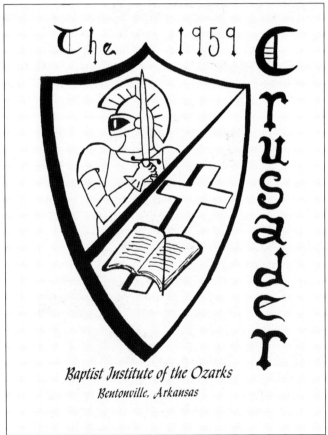

The 1959 Crusader

Baptist Institute of the Ozarks
Bentonville, Arkansas

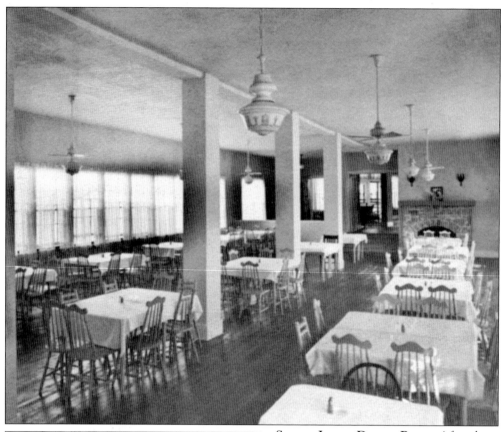

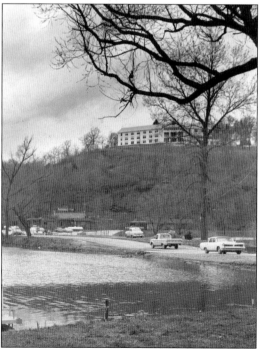

SUNSET LODGE DINING ROOM. After the Baptist Institute of the Ozarks closed, E.L. Keith contracted to sell the Sunset to Tex Newman of Oklahoma City, Oklahoma, who partnered with Audrey Robbins Schweiger to operate it. They hosted several group events, such as conferences and graduations. The dining room was known for its Sunday brunch, which drew people from the surrounding area. Unfortunately, it did not generate a profit, and in 1963, Newman returned it to Keith.

SUNSET LODGE AND DAM, EARLY 1960s. This was taken from the east side of the Lake Bella Vista dam with the Sunset Lodge in the distance. In the center left are the Keith restaurant/grocery store and motel. Note the cars driving across the dam. At the time, this was the only way to cross Little Sugar Creek by automobile to reach the east side of the resort.

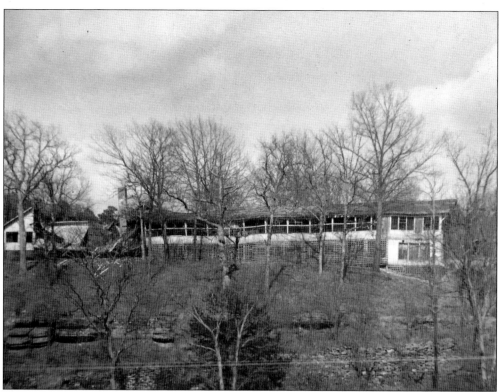

VALLEY VIEW LODGE AND DINING HALL, APRIL 1950. This is one of the last photographs of the Linebargers' Valley View Lodge and dining hall. The lodge had fallen into a deep state of disrepair and was no longer usable. Very shortly after E.L. Keith purchased the resort, he had all the old lodges torn down. It was his desire to remove or rehabilitate all the Linebarger facilities and begin a new era of the Bella Vista Summer Resort.

ANDY DAVIS. Davis was E.L. Keith's wife's nephew who had come to Arkansas to work for him. He was Keith's right-hand man for many years. Over time, Davis also became a favorite of C.A. Linebarger Sr. and apparently filled a role left vacant by C.A. Jr.'s death in 1956. Seven years before C.A. Sr. died in 1978, he gave Davis the 40-acre Wishing Spring Ranch, which is still the property of the Davis family to this day.

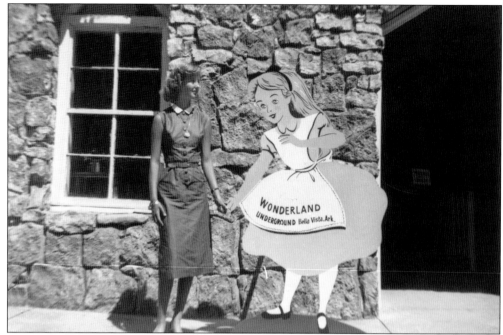

WONDERLAND CAVE ENTRANCE, MID-1950S. C.A. Linebarger's granddaughter, Carole, is shown here at the entrance of Wonderland Cave. Linebarger did not include Wonderland Cave when he sold the resort to E.L Keith but instead continued to operate it as a tourist attraction. Dances were no longer held, but visitors could tour the cave for $1. Caretakers were hired to manage the business, and they lived in the caretaker's cottage next to the cave entrance.

CLYDE WALKER (LEFT) AND FRIEND, TRAFALGAR ROAD. Clyde Walker was one of many farmers in what is now Bella Vista. In this picture from the late 1950s, Walker is shown with an unidentified man on the farm of his son, Lee Edward Walker. The old road going up the hill behind them was located just to the right of today's Trafalgar Road in eastern Bella Vista. After Lee died in 1999, his widow, Elsie, sold the farm, and it is now the site of a large RV facility. (Sam Walker.)

Four

THE COOPER
RETIREMENT COMMUNITY
1964–2006

In 1962, word began to circulate around northwest Arkansas that an unknown entity was buying large sections of land from farmers in the valley north of the Bella Vista Summer Resort. Eventually, it was revealed the buyer was John A. Cooper Sr., who had already proven himself to be a successful developer with Cherokee Village, a retirement community located in north central Arkansas. By 1963, Cooper had acquired 16,000 acres, including the resort, which also gave him the rights to the name Bella Vista. The area was now to be known as Bella Vista Village.

It was Cooper's vision to build a large retirement and recreational community. His chief engineer, James Gore, immediately began platting the land for residential and recreational purposes, with an emphasis on golf courses and lakes, while keeping the original resort as a part of their plans. Under the direction of Cooper and his son John Cooper Jr., Bella Vista grew rapidly. Over time, they gradually expanded its acreage by buying more farms and continued to build golf courses, lakes, and recreational facilities. They created the Bella Vista Property Owners Association and handed over ownership of these properties to the association once construction was complete.

A much-appreciated practice of the Coopers involved them donating land to nonprofit organizations, including churches, with reversionary clauses. The clauses stated that if the organization no longer needed the land, it would revert to Cooper Communities. The knowledge that they had land on which to build and only needed to raise funds for the cost of building a structure gave many groups a head start.

Cooper Sr. also immediately began publishing a monthly newspaper called the *Village Vista*. He helped with the development of many clubs and civic organizations by publicizing them in the newspaper and encouraging more residents to get involved.

The topic of incorporating as a city was hotly debated for many years, but most residents recognized by 2006 that the population of the village had grown to the point where an administrative change was needed. On January 1, 2007, Bella Vista Village was incorporated and became the City of Bella Vista.

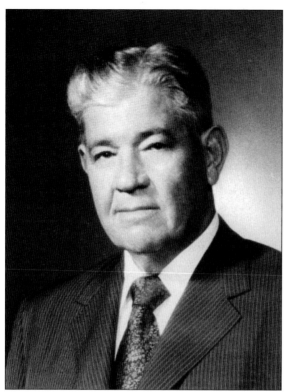

JOHN A. COOPER SR. John A. Cooper Sr. was the president of the Cherokee Village Development Company (later Cooper Communities, Inc.). He is generally credited with pioneering the retirement industry in Arkansas. Cooper's three master-planned communities—Cherokee Village, Bella Vista, and Hot Springs Village—established Arkansas as a retirement destination. Cooper was born in Earle, Arkansas, in 1906 and received a law degree from Cumberland School of Law in Lebanon, Tennessee, in 1927. He was admitted to the Arkansas bar in 1937 and was a partner in the law firm of Cooper and Gatherings from 1927 to 1938. He started his first retirement community, Cherokee Village, in 1954. After it became a success, he opened his second retirement community, Bella Vista Village, in 1965.

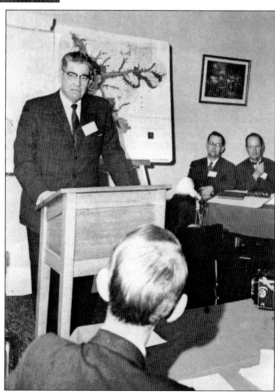

BELLA VISTA VILLAGE PRESS CONFERENCE. John Cooper Sr. explained his plans for the future of Bella Vista Village during this press conference on February 23, 1965.

John Cooper Jr. In 1968, John Cooper Sr.'s son John A. Cooper Jr. took over the reins of his father's company. He was the primary person who oversaw the implementation of his father's plan for Bella Vista. Cooper Jr. worked to forge a close relationship between Bella Vista, the town of Bentonville, and Benton County, which helped contribute to the development of Northwest Arkansas.

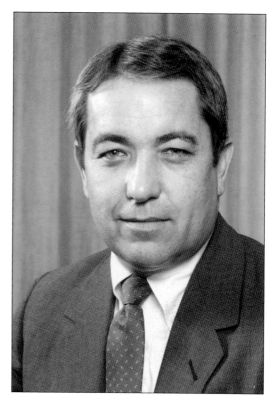

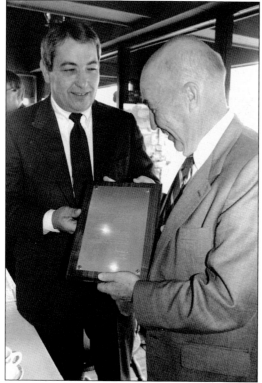

Clayton Little. Clayton Little (on the right) is pictured here with John Cooper Jr. Little was the legal counsel for the Cherokee Village Development Company (later Cooper Communities). It was Little's job to purchase the first tracts of land along Highway 100 (now US Highway 71) for John Cooper Sr. to eventually build the village. Little was a member of the 330th Infantry Regiment in World War II. He received the Distinguished Service Cross, the nation's second-highest combat medal.

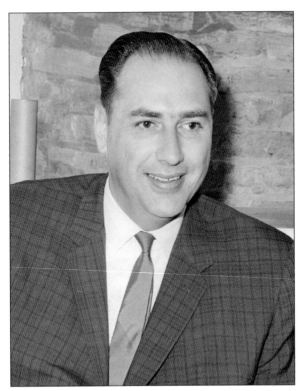

JOE BASORE. John Cooper Sr. was assisted in his business pursuits by his sons-in-law George Billingsley and Joe Basore. In 1965, Billingsley was named vice president and project director for Bella Vista Village. It was under his leadership that the village became the largest of all the Cooper Communities projects. Basore, a brilliant marketing executive, led the marketing efforts for all of Cooper's properties.

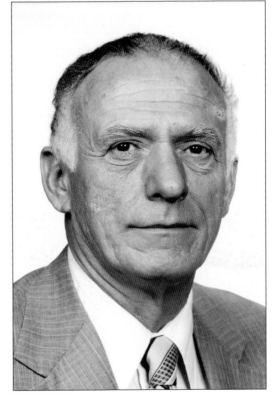

JAMES GORE. In 1962, chief engineer James Gore was sent to evaluate the land around Sugar Creek Valley for development. Gore's job was to examine the geology and hydrology of the valley and determine if it was suitable for lakes, golf courses, and homes. Once it was determined that the land was acceptable, he selected the farms that needed to be acquired in order to make the village a reality.

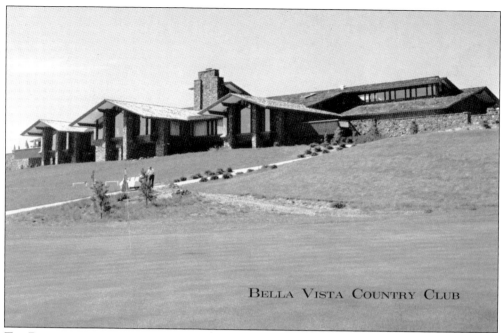

BELLA VISTA COUNTRY CLUB

THE BELLA VISTA COUNTRY CLUB. The cornerstone of the new village was to be the Bella Vista Country Club and its 18-hole championship golf course located on what had been the Howard and Telford farms. The Coopers hired Fay Jones, noted architect and student of Frank Lloyd Wright, to plan a building that would blend with the natural environment. Construction on the country club began in May 1967. The original plan was for a 20,000-square-foot structure to be built of native stone, wood, and glass. It was completed and opened in November 1968 and ended up being a 30,000-square-foot structure and costing nearly $1.3 million. The country club is now listed in the National Register of Historic Places.

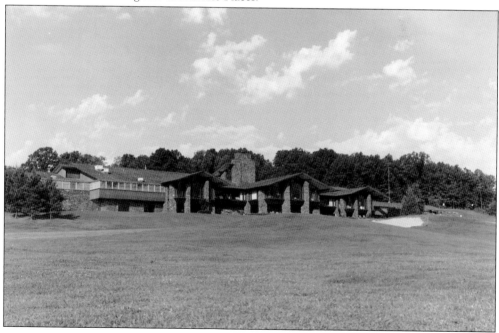

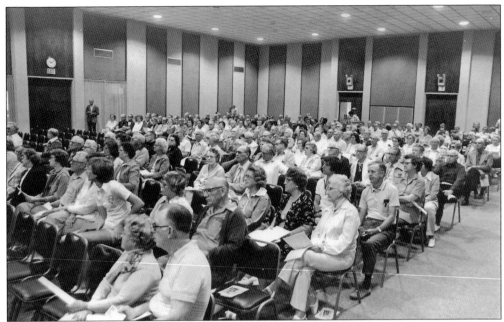

THE PROPERTY OWNERS ASSOCIATION. The primary governing component of John Cooper Sr.'s village was first called the Bella Vista Country Club. In 1973, the named was changed to the Bella Vista Property Owners Association. Members are pictured at the annual meeting in May 1977. Cooper Sr. created the "Declaration and Protective Covenants," which empowered the association to construct, maintain, and administer the common properties and facilities owned by the members.

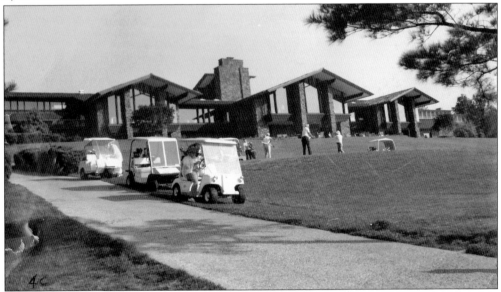

GOLFERS AT THE COUNTRY CLUB. The Bella Vista Country Club Golf Course opened in July 1967. More courses were built in the following years: Kingsdale (18 holes) in 1972, Berksdale (18 holes) in 1978, Branchwood (9 holes) in 1982, Metfield (18 holes) in 1982–1983, Scotsdale in 1986–1987, Highlands in 1989, and an expansion of Metfield in 1999 that resulted in Dogwood Hills (18 holes) and Brittany (9 holes).

GOLF PRO HOGAN ROUNDTREE. Joe Finger of Houston was hired to design the first golf course at the country club. In July 1967, the back nine holes of the course were opened for play. The second nine opened in September 1968. The first resident golf pro was Hogan Roundtree, who was employed by the club from August 1965 until late 1969. Roundtree began playing golf in 1939 and, after serving in World War II, had a successful career as a golfer and golf instructor. One of his students, Davis Love Jr., was a member of the PGA.

CHUCK HOUSE. The second pro at the club was Chuck House, who was hired in November 1969 and remained in that role until he retired in April 1991. House supervised the courses' pro shops and assisted with the construction of the seven additional golf courses in Bella Vista Village.

FOOTBALL COACHES INVITATIONAL GOLF TOURNAMENT. One of the signature golf events at the Bella Vista Country Club was the National Football Coaches Invitational held in mid-June. The event was held at Cooper Communities' various villages, starting with Cherokee Village (from 1965 to 1968), then Bella Vista (from 1969 to 1972), then Hot Springs (from 1973 to 1975). The 36-hole contest drew many nationally recognized coaches to Bella Vista. These included Paul "Bear" Bryant from the University of Alabama, Frank Broyles from the University of Arkansas, Darrell Royal from the University of Texas, and Chuck Fairbanks from the University of Oklahoma. Pictured at left is 1969 winner Vince Carillot (right), of the University of Tulsa, with John Cooper Jr. Coaches Broyles (left), Royal (center), and Fairbanks are pictured below on the course.

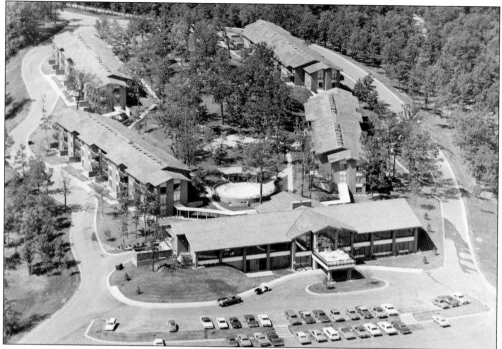

AERIAL VIEW OF CONCORDIA RETIREMENT CENTER, 1970S. Opened in 1972, Concordia, first known as Elcare, was planned by Dr. Edward Cooper, the brother of John Cooper Sr., to provide local medical care. The complex became a medical clinic, an assisted living facility, and a full-service nursing home, and it also contained independent-living apartments and townhouses. An activity building—which now houses a dining area, meeting rooms, and offices—was added later. This photograph shows the activity building and apartment complexes.

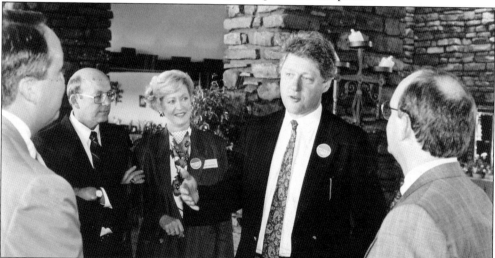

GOV. WILLIAM "BILL" CLINTON. Clinton was the honored guest at the 20th (1985) and 25th (1990) anniversary celebrations of the creation of the village. He served as attorney general of Arkansas from 1977 to 1979, governor of Arkansas from 1979 to 1981 and 1983 to 1992, and as the 42nd president of the United States from 1993 to 2000. Pictured at the Bella Vista Country Club in 1990 are, from left to right, Dennis Canova, Bob DuVall, Gail Rogers, Clinton, and Charles Hughes.

LAKES RAYBURN AND WINDSOR. The building of the country club was accompanied by the rehabilitation of Lake Bella Vista and the construction of the first of Cooper Communities' new lakes. Lake Avalon was started in 1968 just west of the country club. It was created by clearing the valley and damming Sturgeon Creek. Lake Avalon was designated to be a no-wake lake. Construction on the other man-made lakes continued with the growth of the village. Lake Ann was completed in 1970, Lake Norwood in 1973, Lakes Rayburn (above) and Windsor (below) in 1975, Lake Brittany in 1979–1980, and Loch Lomond in 1981. These lakes provided several hundred miles of waterfront lots, boat launches, and day-use areas that, along with the golf courses, became the primary recreational assets of the village.

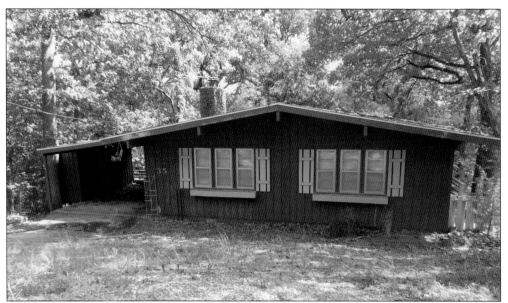

First House and First Full-Time Resident. John Cooper Sr. began selling home lots in Bella Vista Village on May 21, 1965. The first lot was purchased by Ed and Frances Buck of Bentonville. The first home built by Cooper's construction crew was a vacation cottage (above) located on Billingsley Drive and completed in November 1965 for Cleo and Arlie Pettypool from Tulsa, Oklahoma. The Pettypools later recalled how much they enjoyed Bella Vista Village and the $1.25 catfish dinners at the Hill 'n Dale Restaurant. They moved to the village permanently after retiring and were eventually buried in Bella Vista Memorial Garden Cemetery. The first full-time residents of Bella Vista Village were Clifford and Bonnie Mann, who moved from Wichita, Kansas, on January 6, 1966. Their home (below) was located on Gwaltney Circle.

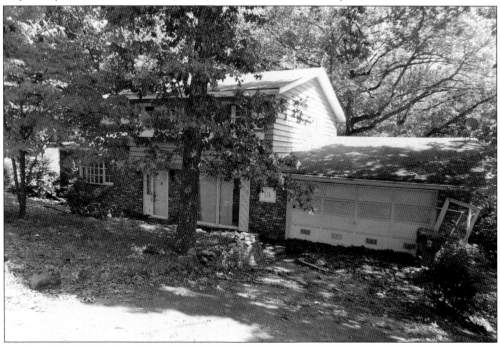

LINDA CASH RUSH. Born in Bentonville, Linda Cash Rush was a lifelong resident of the area. She was raised on a farm in eastern Bella Vista, part of which later became the site of Lake Brittany. She worked for the Bella Vista Property Owners Association from 1968 until 2014. In that time, she welcomed many important guests, including Pres. Bill Clinton, Billy Graham, Lorne Greene, and Pat Boone.

FAY JONES. Architect Fay Jones designed several buildings in Bella Vista Village. An apprentice of Frank Lloyd Wright, he was the only one of Wright's students to receive the American Institute of Architects' Gold Medal (1990), the association's highest honor. In Bella Vista, Jones's best-known contributions are the Bella Vista Country Club and Cooper Chapel. The University of Arkansas Fay Jones School of Architecture and Design is named in his honor. (Don House and the University of Arkansas.)

COUNTRY CLUB AND JOHN DRUM HOUSE. These pictures show the similarities of designs created by architect Fay Jones. Pictured above is a rear section of the Bella Vista County Club. Pictured below is the private home of John Drum located on Lake Windsor. Note the heavy use of straight lines, the abundant glass windows, and the use of native stone, local brick, and hardwood. Jones's mission was to create buildings that would blend with the natural environment of the Ozark foothills and Little Sugar Creek Valley. Jones's designs fit right in with the concept that John Cooper Sr.'s team, under the direction of chief engineer James Gore, had laid out in their creation of the Architectural Control Committee (ACC). To this day, the ACC must approve all new construction and renovations on properties assessed by the Bella Vista Property Owners Association.

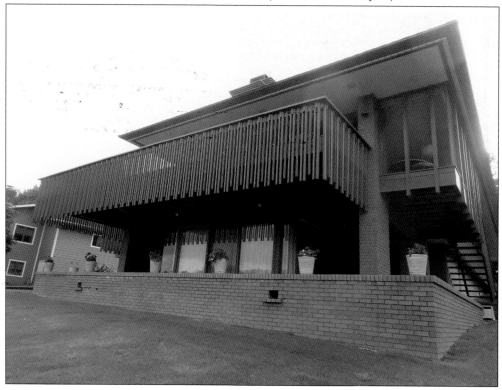

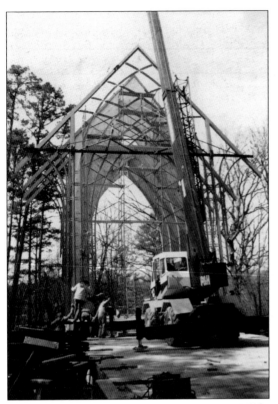

COOPER CHAPEL CONSTRUCTION. One of Fay Jones's most beautiful buildings within Bella Vista Village is the Cooper Chapel. The chapel is named in honor of Mildred B. Cooper, the wife of the founder of Bella Vista Village, John Cooper Sr. Under the guidance of Ann Basore, wife of Joe Basore and the president of the Mildred Cooper Memorial Foundation, over $1 million was raised to complete the structure. Construction began in late 1985, and it was dedicated on August 2, 1988. (Bob Wichert.)

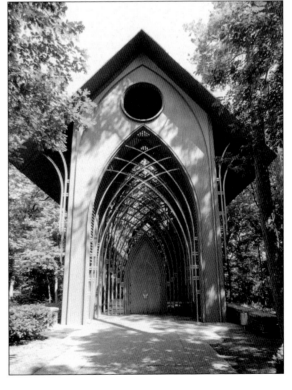

COOPER CHAPEL. Located on the shore of Lake Norwood just east of Town Center, the chapel is 24 feet wide, 64 feet long, and 50 feet in height at its highest point. The structure, which is mostly glass and wood, can seat 120 people. The chapel still serves the public as a venue for weddings, inspirational thought, musicals, and other cultural events. (The University of Arkansas.)

MOBILE HOMES. At first, prospective buyers had to be housed in nearby cities. In 1966, John Cooper Sr. decided to create temporary housing within the village by purchasing 200 mobile homes. Lots were cleared on Skyline Drive and Pisgah Loop for these homes. Cooper's plan was to sell the homes and then rent them back from the buyers for temporary guests to use. Most of these mobile homes still exist today.

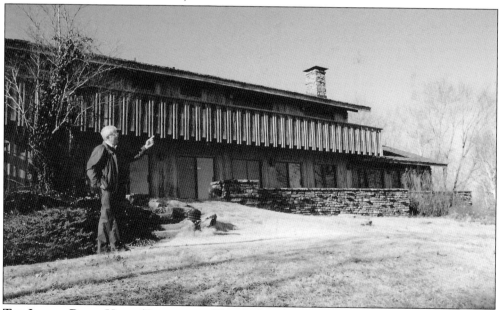

THE INN AT BELLA VISTA (BILLINGSLEY HOME). Another structure that shows the influence of Fay Jones is George and Boyce Billingsley's 9,500-square-foot home located on Chelsea Road and built in 1971. The design of the home was completed by Jones's colleague Albert Green. In 1996, it was sold to Beverly and Bill Williams, who then opened it as a bed and breakfast called the Inn at Bella Vista. Bill Williams is pictured standing at the rear of the inn.

THE WEEKLY VISTA STAFF, LATE 1970s. In July 1965, John Cooper Sr. began publishing his own newspaper, the monthly *Village Vista*, which served as an introduction to Bella Vista Village. In October 1975, it became a twice-a-month publication. On August 3, 1976, it became a weekly publication, which it remains to this day. Standing in the center of the first row (in the white blouse) is Katherine Shurlds, who served as the editor of the newspaper from 1978 to 1980.

ARKANSAS WELCOME CENTER. John Cooper Sr. opened his first welcome center in Cherokee Village in 1963 after seeing such centers in Virginia. In 1966, he donated land near the Missouri border to the Arkansas Department of Parks and Tourism, which opened the first state welcome center on that land in 1967. The Arkansas Welcome Center was moved to its current location near Lake Bella Vista in 1986.

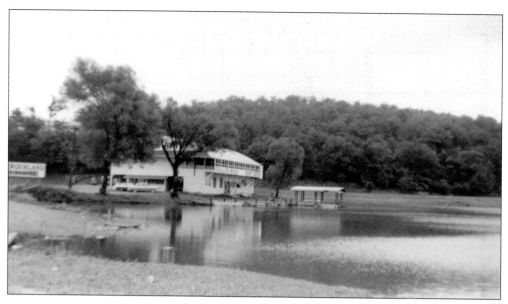

KEITH ROLLER RINK (ABOVE) AND HILL 'N DALE RESTAURANT (BELOW). E.L. Keith's roller rink and boat dock was located at the northern end of Lake Bella Vista and is pictured just before it was purchased by John Cooper Sr. The structure, which began as a dance pavilion built by C.A. Linebarger in 1931, had a variety of different uses during the Cooper period. In the 1968 photograph below, it was the Hill 'n Dale Restaurant. The restaurant opened in 1965 under the direction of Joe and Elsie Bell. It was located on the first floor, and the second floor was used for special events and activities. Hill 'n Dale Restaurant was operated by several managers until it closed in 1985. The building became the Sugar Creek Mall, then the Country Creations Mall, which it remained until an electrical fire destroyed the structure in 1998.

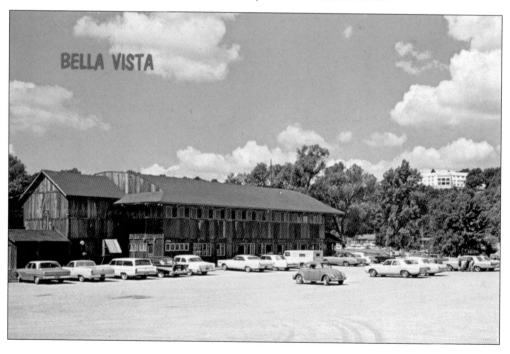

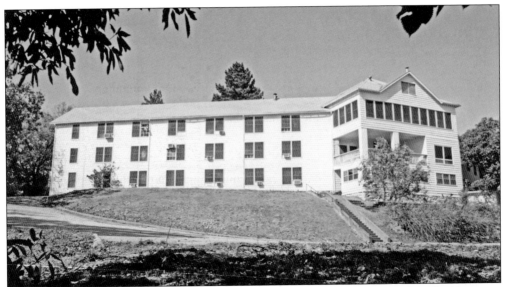

VILLAGE HALL. After acquiring the Sunset Hotel, John Cooper Sr. converted the building into his headquarters for Bella Vista Village, renaming it Village Hall. Several departments, including sales and the *Village Vista* newspaper, were housed here. Remodeling of the building included adding window air-conditioning units (as shown above) and enclosing part of the back porch to make it into space for the sales office. The parking lot was paved, and a playground was built for children to play while their parents were conducting business inside Village Hall. In the 1965 photograph below, a group of media representatives had arrived by bus for a press conference about the village. Cooper used Village Hall as his headquarters until he moved the entire administrative operation to Town Center in 1992.

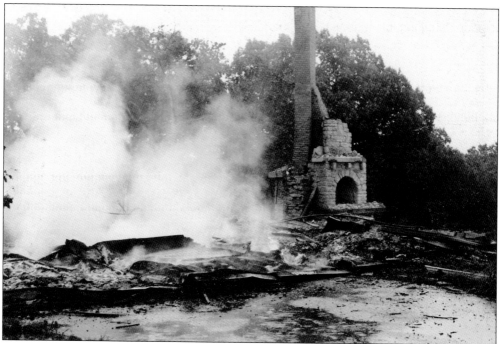

FIRE. One of the greatest tragedies to occur at Bella Vista Village was the fire that destroyed the Sunset Hotel/Village Hall in the early morning hours of July 1, 1999. Fire was the great enemy of Bella Vista since its beginnings in 1915. A fire in September 1936 destroyed eight rooms in Valley View Lodge. In March 1939, a fire ignited by a lightning strike destroyed eight cottages on the west side of the Bella Vista Summer Resort. A fire in 1951 that was caused by embers from leaves being burned in a fireplace destroyed several cabins on the east side. These two photographs show all that remained after the fire that destroyed the Sunset Hotel. The building, which had sat empty after the village's administrative offices were moved to Town Center in 1992, was the victim of an arsonist. (Above, Gil Fite; below, Gene Heezen.)

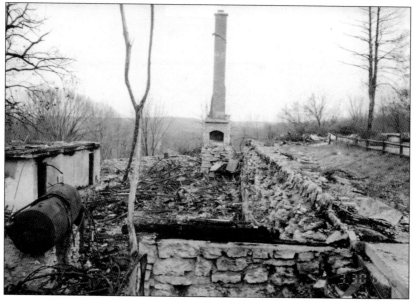

HENRY ANDERSON (LEFT) AND A WEEKLY VISTA CARTOON. Over the years, Bella Vista's newspaper, the *Vista*, was fortunate to have several talented editorial cartoonists. One who stands out is Henry Anderson. He was the paper's first editorial cartoonist, starting in 1976 and remaining until his death in 1981. Over 300 of his original cartoons are stored in the archives of the Bella Vista Historical Society. In 1999, the society published a book of his works entitled *Brush Strokes*. The cartoon shown below is typical of Anderson's humor. A herd of bison, which started as a gift to John Cooper Sr., became the unofficial mascots of Bella Vista Village and drew a great deal of attention from curious visitors. Anderson's work appeared in the *Saturday Evening Post*, *Better Homes and Gardens*, and *Successful Farming*. He also designed the logos for local businesses and did sketches of nature and Bella Vista landmarks.

PHIL SCIUMBATO AND THE BELLA VISTA ANIMAL SHELTER. In the early 1980s, Bella Vista was facing the problem of how to care for abandoned animals. At the time, the only facility for keeping animals was a fenced-in area around a propane tank at the Benton County sheriff's office at Town Center. Pictured at right is Capt. Phil Sciumbato. With the support of the *Weekly Vista* and the Bella Vista Property Owners Association, Sciumbato began the effort to create a more humane facility for the animals. He started at what remains the shelter's current location on a landfill at the northern edge of town near the Missouri line. Through donations and the efforts of volunteers like Karen Dobbs (center) and Dr. Dick Arnold (right), pictured below with Captain Sciumbato, the facility eventually became a reality. It is a 501(c)(3) nonprofit thanks to the efforts of Captain Sciumbato and volunteers.

JOHN RIORDAN (ABOVE) AND RIORDAN HALL (BELOW). John Riordan was hired in 1968 as vice president for community services for the Cherokee Village Development Company (later named Cooper Communities), but his main responsibility was to manage the Bella Vista Property Owners Association, then known as the Bella Vista Country Club. He was also on the board of the association, serving as president from 1971 until he retired in 1975. A native of Wisconsin and a graduate of Marquette University, Riordan had a successful career in food services and, later, with country clubs in Texas before he was hired by John Cooper. In July 1972, he announced the design and construction of a new recreation building to be built as part of the Kingsdale Center. The new building was completed in 1973 and named after him. Riordan Hall, with its large auditorium and meeting rooms, became the village's community center.

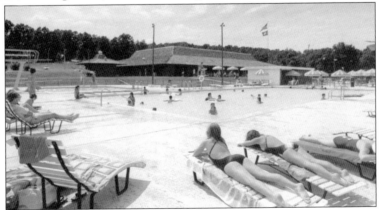

WEST END SALES OFFICE, 1979. Cooper Communities began development of the Highlands area of western Bella Vista in the early 1970s and built a sales office at the west end of the Loch Lomond dam in 1976. Here, a group of prospective buyers and a salesperson standing on the porch of the sales office are looking out at the construction of the dam. The office was demolished in 1995 to make room for private homes.

LOCH LOMOND CONSTRUCTION. Loch Lomond is the largest of the lakes created by Cooper Communities. Construction on the 477-acre lake began in 1978 and was completed in 1981. The project was also slated to have a marina and clubhouse; after much debate, these were started in 1987 and completed in 1988. The facility was named the Loch Lomond Yacht Club and Marina. The total cost of the Loch Lomond project was just under $5 million.

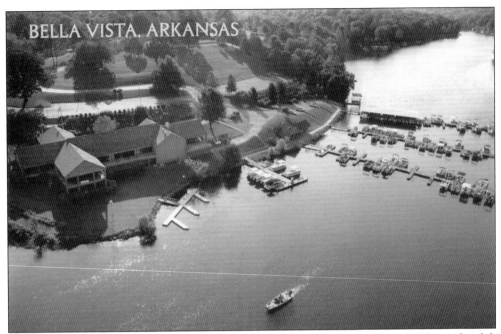

BELLA VISTA, ARKANSAS

AERIAL VIEW OF LOCH LOMOND YACHT CLUB (ABOVE) AND FISHING (BELOW). The yacht club and marina was the cornerstone of the Loch Lomond recreational facilities. The above image shows the completed project. The 15,000-square-foot clubhouse contained a snack bar, kitchen and storage space, dining/meeting rooms, a lounge, and spacious outside decks. The building was designed by architect John Younkin of the Stuck Associates and, as with all Bella Vista Village facilities, was designed to blend in with the natural environment. The marina provided covered and uncovered slips for boats, a bait shop, fishing piers (as shown below), and a fuel station. Dave Howard was the marina manager from its opening in 1988 until his death in September 1999. The marina was then leased to a contractor until it returned to Bella Vista Property Owners Association management in March 2019. Loch Lomond provides excellent fishing for largemouth bass, crappie, bluegill, and catfish.

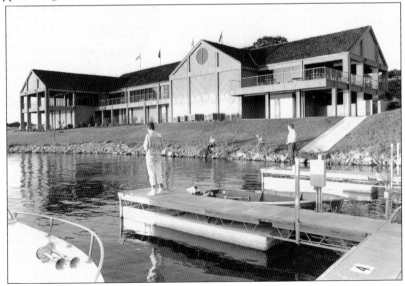

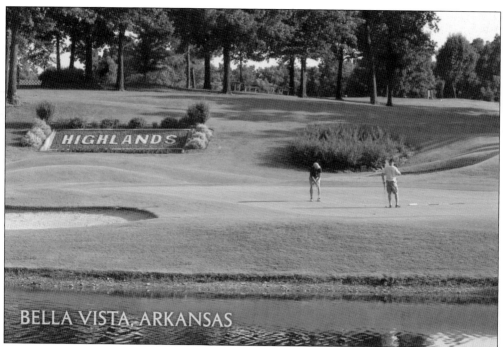

BELLA VISTA, ARKANSAS

HIGHLANDS GOLF COURSE AND "MR. MULLIGAN." The last of the golf courses to be completed was the Highlands course in June 1989. The course won immediate praise for being one of the best in Arkansas. Pictured above is the challenging par-three ninth hole, where golfers, under the watchful eyes of visitors in the clubhouse, must hit across a large pond to reach the green. The Highlands clubhouse was completed in October 1989 at a cost of $1.1 million. The 7,200-square-foot structure contained a pro shop, dining room, kitchen, meeting room, and a bar and lounge. One of the unique features of the Highlands course is the statue of "Mr. Mulligan." It was created in 1996 by Clayton Cross, a chain-saw artist from Oklahoma, from a tree stump located in the parking lot. (Right, George Kurland.)

VILLAGE ART CLUB. The Village Art Club was organized in the early 1960s. The club's studio, pictured on the left in this image, is located next to the Wishing Spring Art Gallery. In 1982, the club leased the property from Cooper Communities, which donated it to them in 1999. The club produces the Bella Vista Arts and Crafts Festival, which has been held every October since 1969 (except in 2020). Today, the club is known as the Artisan Alliance at Wishing Spring.

BELLA VISTA BIG BAND. Bella Vista Village has had many musical groups. One of the most popular was the Bella Vista Big Band. The band was formed in 1989 to present local concerts. They also performed at Pres. Bill Clinton's inaugural balls in Washington, DC, in 1993 and 1997. Other musical groups included Barbershop Harmony Choruses, the Organ Belles, the Bella Vista Men's Chorus, the Village Handbell Ringers, and the Bella Vista Community Concert Band.

MAXINE ICKIS (RIGHT) AND *THE TWELVE SOLILOQUIZE*. One leading resident of Bella Vista Village in its early years was Maxine Ickis. She was a native of Iowa and had attended the University of Nebraska, majoring in drama and music. After retiring, she and her husband, Ralph, moved to Bella Vista Village in 1972. Her greatest contribution was the production of the play *The Twelve Soliloquize*. The play was a rendition of the feelings, through words and music, of all the participants in the Last Supper. The play was presented every year on Good Friday to a packed Riordan Hall. It was so well received that many local churches canceled Good Friday services and urged their congregations to attend the play. Tragically, Maxine and Ralph were killed in a car accident in 1979. The play continued to be performed every year until 1998.

VILLAGE PLAYERS. The Village Players was a theatrical organization created by residents. Organized in June 1965, it was one of Bella Vista's first community groups. This picture is from a performance of *The Mouse that Roared* in 1994. From left to right, the actors are Steve Hudson, Ginger Hamilton, W.L. Anderson, Alice Messier, Rodney Johnson, and Mary Solliday. The group gave its last performance in May 2013. The group was reborn in 2018 under the name Playwerks.

VILLAGE FINE ARTS ASSOCIATION. Another early organization was the Village Fine Arts Association, which started in November 1976. The purpose of the association was to provide cultural programs. Instead of using local talent, this group booked musicians and other performers from out of town. This became the Village Performing Arts Association in 1989 and then Live on Stage in NWA (Northwest Arkansas) in 2006. The group was disbanded in 2015. Pictured here are the group's officers from May 24, 2005.

CIVIC CLUBS AND GARDEN CLUB. Bella Vista has always been home to a variety of civic and social groups. Among the civic groups were the Kiwanis (above), the Lions, Rotary, and the Nomad Shrine Club. Social groups included the Bella Vista Women's Club, golf clubs, the Pioneer Club, the Fly Tyers, the National Association of Active & Retired Federal Employees, the Bluebird Society, the Photography Club, the Woodcarvers, the Christian Women's Club, and the Computer Club. Other groups offered residents a chance to enjoy activities such as hiking, dancing, camping, bowling, playing cards, quilting/needlework, painting/ceramics, and boating. Several residents formed clubs with others from their home city or state. Of special note is the Garden Club, organized in 1972. The club was responsible for the creation of the Living Memory Garden (below) at the Bella Vista Country Club in 1979.

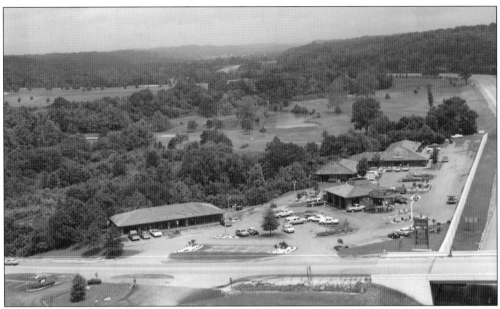

AERIAL VIEWS OF TOWN CENTER WEST (ABOVE) AND SUGAR CREEK PLAZA (BELOW). As Bella Vista grew, there was an increased need for shopping facilities. Among the first projects were Town Center West and Town Center East. These centers were built in the early 1970s at the intersection of US Highway 71 and Lancashire Boulevard. The centers have held several businesses, including Harps Foods in Town Center East, which is still in operation. Town Center West was demolished in 2020. In 1994, construction began on Sugar Creek Center (at right in the below photograph that looks north along Highway 71). This center has also been home to various businesses. It has been anchored by Allen's Food Market since 1999, managed by community leader Steve Morrow. Other shopping centers in Bella Vista include Cunningham Corner, Greenwich Centre, and Village Center. (Below, Bella Vista Property Owners Association.)

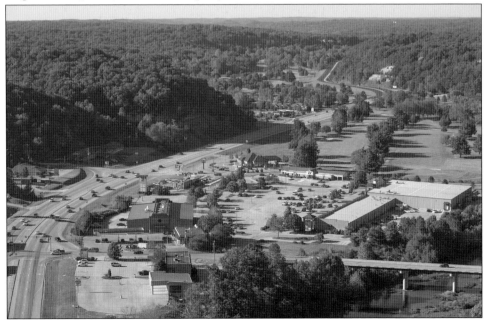

MACADOODLES AND WALMART SUPERCENTER. Shopping options for Bella Vista residents changed in the late 1990s and early 2000s. Benton County, Arkansas, where Bella Vista is located, was a dry county starting in 1944, so for years, residents patronized small liquor stores along the Missouri state line at the north edge of Bella Vista. After 1944, alcohol could still be served but only by purchasing an annual membership in a restaurant's private club. Macadoodles opened a large liquor store in 1997 just north of the state line. In 2005, Walmart opened a Supercenter across US Highway 71 from Macadoodles and added a large liquor department. In 2012, Benton County voters overturned the 1944 dry ordinance, allowing for alcohol sales within Bella Vista. Despite the competition, Macadoodles and Walmart have continued to have successful liquor sales to this day.

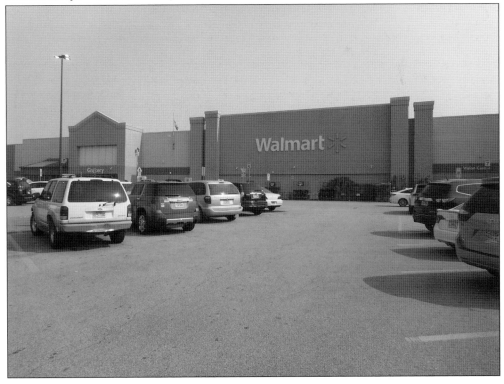

Bella Vista Historical Museum and Larry Swain. In 1976, in conjunction with the national bicentennial celebration, a group formed the Bella Vista Historical Society, which initially met at the Hill 'n Dale restaurant. Eventually, Cooper Communities offered the group land adjacent to the American Legion, at the corner of Kingsland and US Highway 71, for a permanent museum. They raised funds for a prefabricated structure (pictured above), which was assembled in 1984. The museum opened to the public in April 1985. Many people contributed to the long-term success of the historical society, but one of the early advocates was Larry Swain (pictured at left in the below image). He had been interested in archaeology since childhood and served as president of the Northwest Arkansas Archaeological Society. After becoming involved with the Bella Vista Historical Society, he served in several roles, including president and, later, educational coordinator.

GILBERT FITE. Two previous books have told the history of Bella Vista. The first, *The Bella Vista Story*, was edited by George Phillips and Robert Cheyne and published in 1980. The second was *From Vision to Reality – A History of Bella Vista Village 1915–1993*, by Gilbert Fite (pictured here). Fite was an accomplished academic and historian. Among other positions, he held the Richard Russell professorship of American History at the University of Georgia.

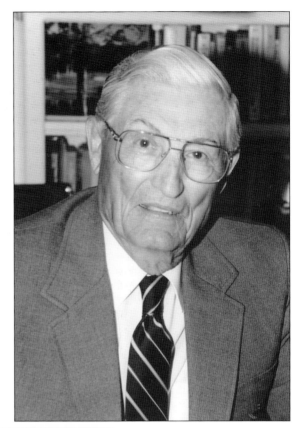

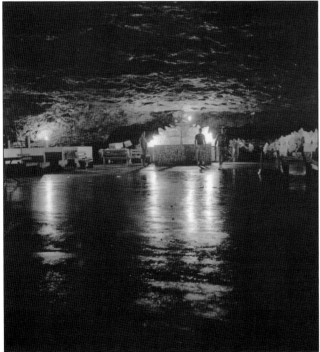

THE COOPER ERA OF WONDERLAND CAVE. In 1965, John Cooper Sr. signed a 20-year lease to use Wonderland Cave for parties, special events, guest tours, and more. The Linebarger heirs next sold the cave in 1988 to local businessmen who operated it as a club until 1995. Unable to make a satisfactory profit, the men returned it to the Linebarger heirs, who sold it again in 1996 to a businessman from California. When that venture failed, ownership of the cave passed to the businessman's investors. In 2019, those investors sold the cave to Dartmoor Road LLC.

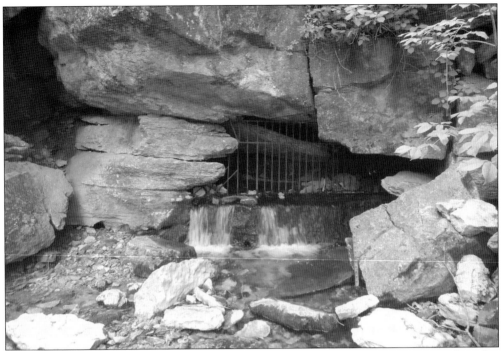

BLOWING SPRINGS RECREATION AREA. Following the deaths of Joseph and Mary Mills, Mills Valley and its abundant spring (above) were owned by several individuals, one of whom was Bob Cates, an oilman from Tulsa. In the early 1920s, the property, then called the Beal Place, was rented by Zach and Ann Bolain, and they lived there until Zach's death in 1944. From the 1920s to 1965, when the property was purchased by Cooper Communities, it was known as Bolain Springs. Cooper Communities changed the name to Blowing Springs shortly after the purchase and developed the area around the spring into a general recreation area. It now includes hiking trails, an RV park, an outdoor stage, and a picnic area. The picnic area (below) became the location for many social events sponsored by the Bella Vista Property Owners Association.

HIGHLANDS CROSSING (ABOVE) AND BELLA VISTA COMMUNITY TV (BELOW). Another major construction project undertaken by Cooper Communities was Highlands Crossing. Completed in 1989 and located at the intersection of Arkansas Highways 340 and 279, it was built to be the headquarters for Cooper Communities. In 2002, Cooper Communities moved its headquarters to Rogers, and the building was donated to the Bentonville–Bella Vista Community Development Corporation (CDC). It was remodeled into apartments on the upper level plus offices for nonprofit organizations. The lower level has served various purposes, including as classrooms for the Northwest Arkansas Community College and a restaurant; it has been the home of the Bella Vista Community TV station for several years. The CDC also built other housing nearby, including the Cottages at Highlands and the Plaza for senior independent living.

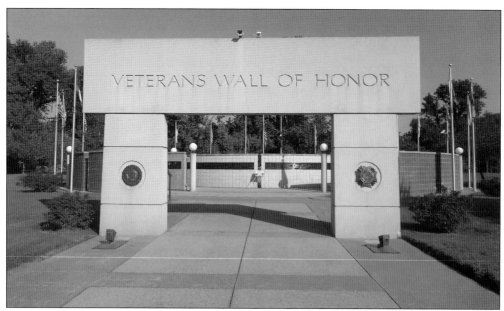

Veterans Organizations and the Wall of Honor. Bella Vista is home to American Legion Post 341 and was home to Veterans of Foreign Wars Post 9063 (now disbanded). Together, they formed the Veterans Council of Northwest Arkansas to raise funds and create a Wall of Honor Memorial for veterans. The project began in 2001, and the first phase was completed in 2004. The memorial is located at the north end of Lake Bella Vista.

Bella Vista Residents Meet with Governor Huckabee. The idea of the village becoming a city began in 1977. After much debate, state representative Shirley Borhauer sponsored a bill to let voters decide on incorporation without a petition-signing process. Here, residents, Borhauer (third from the left in the first row), and Gov. Mike Huckabee are shown meeting in support of this bill. In November 2006, the village voted to become the City of Bella Vista in January 2007.

Five

THE CITY OF BELLA VISTA
2007–TODAY

On January 1, 2007, Bella Vista Village became the incorporated City of Bella Vista. The new city government was to be led by a mayor and city council and be responsible for the street, fire, and police departments; the library; the district court; and community development.

The Bella Vista Property Owners Association (POA) remains a major part of the community and is responsible for the maintenance and construction department, the water department, member services, and all recreational facilities, including clubhouses and golf courses, lakes, tennis courts, and fitness centers. There is also a separate townhouse association that serves over 1,000 owners of townhouses built by Cooper Communities over the years.

The Architectural Control Committee oversees the construction rules and regulations of homes and facilities built on POA-assessed properties. It enforces strict guidelines regarding the type and size of homes that can be built, the colors of paint that can be used, and the type and placement of fences and storage sheds. These regulations are in place to ensure that homes and facilities continue to blend with the natural surroundings that have been part of Bella Vista's history since the Baker and Linebarger years.

The Bella Vista Historical Society—an independent, nonprofit, all-volunteer organization—receives financial assistance from the city and some services provided by the POA. The society operates and maintains several properties, including the Bella Vista Historical Museum, the C.C. Cooper Settler's Log Cabin, the Summit School/Church site and cemetery, and the 1927 Linebarger water tank property.

Today, over 30,000 people call Bella Vista home. With retirees making up less than 33 percent of the population, Bella Vista has evolved from a retirement community to a bedroom community supporting major employers in Northwest Arkansas, including Walmart, Crystal Bridges Art Museum, Tyson Foods, and J.B. Hunt. It is home to a younger population who moved here from all over North America. It now has over 100 miles of biking and hiking trails maintained in a joint agreement between the city and the POA in addition to the recreational facilities. Bella Vista has truly become the wonderful place to live and thrive that was envisioned by the Bakers, the Linebargers, E.L. Keith, and the Coopers.

MAYORS FRANK ANDERSON (ABOVE) AND PETER CHRISTIE (LEFT). When Bella Vista Village became the City of Bella Vista in January 2007, there was a need for a new center of government. Since then, the city has had two mayors, Frank Anderson, who was in office from 2007 to 2014, and Peter Christie, who has been in office from 2015 to the present. Anderson was with the US Air Force for 28 years prior to retiring to Bella Vista. He was chairman of the Bella Vista Property Owners Association before becoming mayor, then served on the city council afterward. Christie was in the corporate world for 33 years, with his last position being in charge of the NCR Corporation account with Walmart prior to his run for mayor. (Above, Terri O'Byrne; left, Peter Christie.)

POA Building and Tom Judson. The Bella Vista Property Owners Association (POA) continues to be a major contributor to the day-to-day lives of residents and their guests. The original POA building (pictured above) was converted into city hall after the city incorporated in 2007, and the POA management offices were moved to the Bella Vista Country Club. The POA, through the collection of property assessments and user fees, operates the water department and manages the recreational facilities, which include the lakes, golf courses and clubhouses, swimming pools and beach, tennis courts, restaurants, meeting facilities, a gun range, and the hiking and biking trails (which it manages along with the city). Pictured at right is Tom Judson, chief operating officer of the POA. After attending college in California and working in the golf industry for 22 years, Judson came to Bella Vista from North Carolina in early 2016. (Right, Tom Judson.)

BIKE TRAILS AND TRAILBLAZERS. In 1996, the Bella Vista Chamber of Commerce Leadership Class decided that its community project would be to build hiking/biking trails. After forming a nonprofit called Trail Blazers, they started with a trail around Lake Bella Vista. The Back 40 in eastern Bella Vista became the first 40 miles of a 100-mile network of trails within the city. With help from the Walton Family Foundation, trail-building has exploded across Northwest Arkansas.

LAKE AVALON. In 2018, the first Bella Vista swimming beach was constructed at the west end of Lake Avalon by the Bella Vista Property Owners Association (POA). It soon became a big attraction for POA members. In addition to the large sandy beach, there is a swim area, beach volleyball court, paddleboard and kayak rentals, and a small concession stand. The largest of Bella Vista's no-wake lakes, Avalon is a favorite among kayakers and canoeists.

BELLA VISTA MEMORIAL CEMETERY. Established in 1984 and supported by 10 Bella Vista churches, the Bella Vista Memorial Garden Cemetery serves the community as a final resting spot for many of its residents. The cemetery grounds include the historic Buxton Cemetery, the burial site of area pioneers. The Bella Vista area has at least 10 known cemeteries, with some of them containing only two or three graves but all important to the preservation of the area's history.

TH ROGERS LUMBER COMPANY AND BELLA VISTA BUSINESS ASSOCIATION. As the number of businesses increased over the years, there was a need for greater coordination. Formed in 1982, the Bella Vista Business Association (BVBA) filled that role. In 2020, there were 95 businesses in the association. Pictured here are employees of one of the BVBA's longtime members, TH Rogers Lumber Company. Note the face masks that everyone was wearing in 2020 because of the COVID-19 pandemic.

US Highway 71 Bypass. Highway 71 was widened to four lanes through Bella Vista in 1978, but by 1990, it became apparent that a bypass was needed, especially due to the increasingly heavy truck traffic. By 2000, a route west of Bella Vista had been decided upon to connect the future interstate highway, Interstate 49, from Bentonville to Pineville, Missouri. Work began in 2011 and is scheduled to be completed by the end of 2021.

Cancer Challenge and Phillips Classic. In 1986, John Phillips (pictured), of the former Phillips grocery chain, sponsored a fundraising event called the Phillips Classic in Bella Vista for local cancer treatment centers. He raised $4.2 million through 1993, using national celebrities as participants. The Cancer Challenge replaced the Phillips Classic and continues today with the help of hundreds of volunteers and many corporate sponsors. The organization has invested over $13.2 million in the area.

COOPER SCHOOL AND STABLES. As families with children moved into Bella Vista, the need for an elementary school became apparent. In 1996, Cooper Communities offered to donate land that held the old stables barn for a school if it was built within 10 years. The barn was torn down in 2006, and Cooper School opened in the fall of 2007 for students in kindergarten through fourth grade. After fourth grade, Cooper School students go to Bentonville schools.

THE FIRST LIBRARY. Bella Vista Village's first library was established by volunteers in 1981 in Riordan Hall. In 1986, it moved to Town Center West, and Lila Wylie (left) was hired as a librarian in 1990. After a fundraising drive that spanned several years, a new library was constructed on Arkansas Highway 340 just east of Town Center and opened in 1996. The library became a department of the City of Bella Vista in 2014.

THE POLICE DEPARTMENT, CRIME WATCH PROGRAM, AND THE FIRE DEPARTMENT. The City of Bella Vista Police Department has an unusual history. It began with security guards hired by Cooper Communities. In 1981, they were made deputies of the Benton County Sheriff's Department, by which time they were being paid by the Bella Vista Property Owners Association (POA). When the city incorporated in 2007, the current police department was created. The POA created a Crime Watch Program in 1979, which became the Neighborhood Watch Program in 2012. The fire department was started by the POA in 1969 as an all-volunteer force, most of whom were employees of Cooper Communities, with Donald Grisham serving as an unpaid fire chief. The first paid fire chief, William Beck, was hired in 1972. An ambulance and rescue service was added in 1976. (Both, City of Bella Vista.)

Mercy Clinic. Mercy Health is a not-for-profit Catholic healthcare organization headquartered in St. Louis. It opened the Mercy Clinic in Bella Vista in December 2013 on Mercy Way, the former Dartmoor Road that was renamed for the facility. The building is also home to Cornerstone Pharmacy, which opened on US Highway 71 in Bella Vista in 2009 and moved to the Mercy Clinic when the clinic opened.

Recycle Center. Wally Sheldon was among those who started the local chapter of the American Association of Retired Persons (AARP) in Bella Vista in 1971. In 1976, Cooper Communities partnered with AARP to open a recycling center, with proceeds going to local charities. It is now considered a model for the rest of Arkansas. AARP Chapter 109 became inactive in 2016, but the Bella Vista Recycling Center continues as a nonprofit foundation. Volunteer Sue Carrington is pictured here in 1998.

TANYARD NATURE TRAIL. One of the most visited sections of trail in Bella Vista is the Tanyard Creek Nature Trail. Designed by Dave Wiemer, it was under construction by early 1991 thanks to a large group of volunteers with assistance from the Bella Vista Property Owners Association and Cooper Communities. The two-mile trail winds through scenic valleys with a suspension bridge across Tanyard Creek and an overlook at the Lake Windsor spillway, which is shown here.

LINEBARGER WATER TANK. This water tank was built in 1927 by the Linebargers. Water was piped from Big Spring through hydraulic rams under Lake Bella Vista and traveled uphill for a mile to the tank. It then flowed back downhill for use at cottages below it and at the Sunset Hotel. The tank was listed in the National Register of Historic Places in 1992. It was given a new roof in 2016 and is now owned by the Bella Vista Historical Society.

BOLAIN BARN (ABOVE) AND NEUENSCHWANDER BARN (BELOW). The Bolain Barn, located on the east side of Bella Vista, has an interesting history. It was being built in the 1920s to be a church, but when the financial crisis swept the country after the stock market crash in 1929, the bank that held the congregation's money failed. With the church's money gone, the partially completed building sat idle until it was purchased by C.A. Linebarger. He finished it as a barn, but the windows were kept, which made it unique for that type of structure. Today, it has been restored and is a business office. The Neuenschwander Barn, built around 1903, is in Sugar Creek Valley just south of the Bella Vista Property Owners Association golf maintenance building. Today, it is used as a storage space for the golf maintenance department.

BELLA VISTA'S 100TH ANNIVERSARY. In 2015, the Bella Vista Historical Society celebrated the 100th anniversary of the construction of Lake Bella Vista. Alongside the lake, a large tent was erected that held several historical exhibits and featured special guests, including Constance Waddell, who autographed copies of her book *Sally and Me.* Bob Williams (pictured), the great-nephew of photographer Lillian Green, helped visitors identify family photographs that Green had taken.

HALE LOG HOUSE, THE LINEBARGER HOME. The oldest remaining structure in Bella Vista, the Hale Log House, was purchased by the Linebargers in 1917 along with the Lake Bella Vista property. Nearly a century later, in 2011, Sara Parnell bought it to start the Artist Retreat Center and further expanded it with the rearmost addition. She sold the property in 2020 to new owners. This picture shows the log house at the time of the 2020 sale.

BELLA VISTA BAPTIST CHURCH (ABOVE) AND ROAD CONSTRUCTION (BELOW). Churches have always played an important role in the lives of the residents of Little Sugar Creek Valley and Bella Vista. In the beginning, churches were the heart of the farming community, and later, of the resort and retirement communities. The first church built during the Cooper era was the Bella Vista Baptist Church constructed in 1973. By 2020, there were approximately 30 churches in Bella Vista, many of which were built on land donated by Cooper Communities. When the Church of Jesus Christ of Latter-Day Saints decided to build at the corner of Kingsland Road and Lambeth Drive in 2013, across the street from the new Jehovah's Witnesses church, the church offered to cut down the hill by eight feet (pictured below) to increase visibility for traffic. This helped decrease the risk of accidents at that intersection.

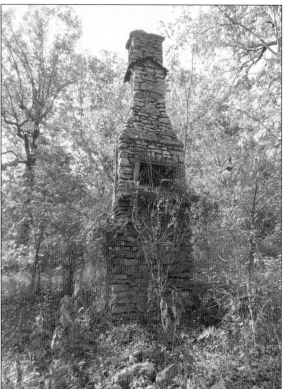

REMAINING LINEBARGER COTTAGES AND A CHIMNEY. Only a handful of the cottages built during the Linebarger years (1917–1952) remain standing. Some were lost in fires, some simply deteriorated over the years, and some were demolished to make room for modern structures. Pictured above is one still in use today, the Hagler Cottage, located above the east side of Lake Bella Vista. Most of the remaining cottages are still owned by the descendants of the families who purchased them years ago. Today, several chimneys still stand in the original part of Bella Vista as silent sentinels from a bygone age. Solidly built, these nearly 100-year-old chimneys and a few foundations are all that remain as a reminder of people's connection to the land, to the springs, and to the memory of those who came before.

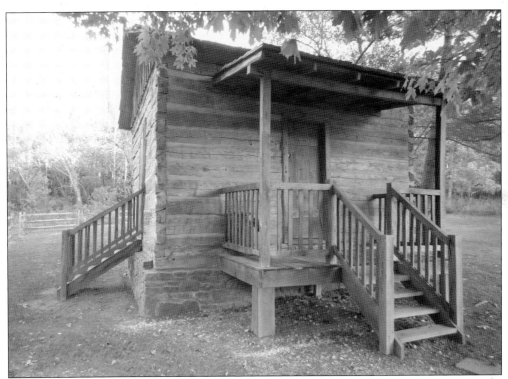

SETTLER'S CABIN, BELLA VISTA HISTORICAL MUSEUM, AND THE AUTHORS. Now located on the grounds of the Bella Vista Historical Museum, the Settler's Cabin, which was built around 1912 by C.C. Cooper, was saved from demolition by Paul Parish in 1974. Parish moved the cabin to his home on Lake Avalon for use as an art gallery. After Parish's death in 1997, the cabin was purchased by Scott and Angie Butler, who donated it to the museum in 2018. It was moved, restored, and opened in 2019. Pictured below are Dale Phillips and Xyta Lucas, the authors of this book, who served as the 2020 copresidents of the Bella Vista Historical Society, which operates the museum. The museum is staffed by volunteers and is open year-round from 1:00 p.m. to 5:00 p.m. Wednesday through Sunday. It is supported by membership dues and donations, as well as financial assistance it has received from the City of Bella Vista since 2013. There is no admission charge.

DISCOVER THOUSANDS OF LOCAL HISTORY BOOKS FEATURING MILLIONS OF VINTAGE IMAGES

Arcadia Publishing, the leading local history publisher in the United States, is committed to making history accessible and meaningful through publishing books that celebrate and preserve the heritage of America's people and places.

Find more books like this at
www.arcadiapublishing.com

Search for your hometown history, your old stomping grounds, and even your favorite sports team.